"I feel a power in me which I must develop, a fire that I may not quench, but must keep ablaze, though I do not know to what end it will lead me, and shouldn't be surprised if it were a gloomy one."

Vincent van Gogh to his brother Theo in November 1882

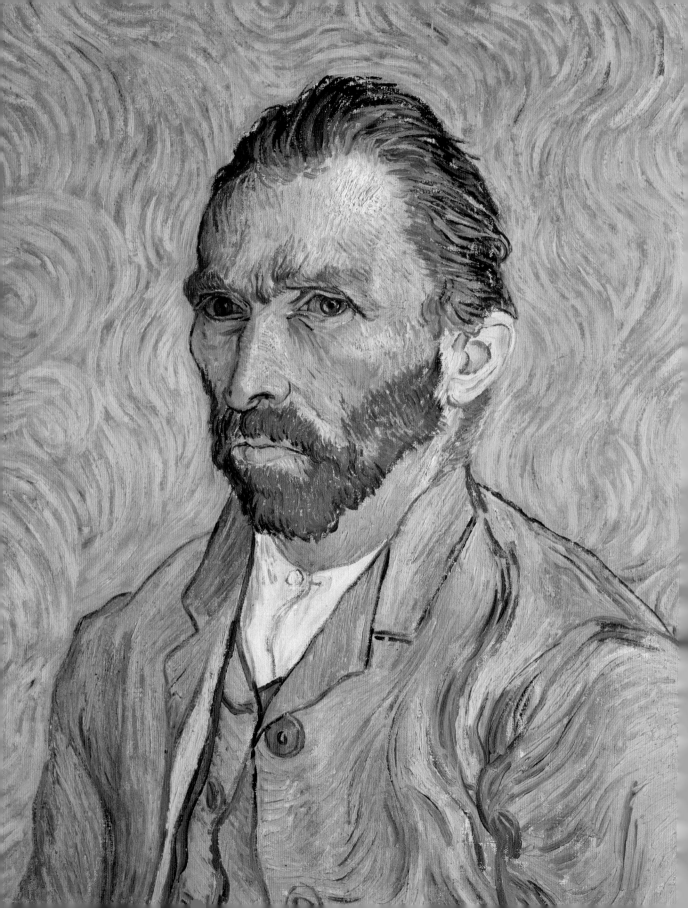

VINCENT VAN GOGH

Isabel Kuhl

PRESTEL

MUNICH · BERLIN · LONDON · NEW YORK

Contents

"I mean painting is a *home* ..."

Vincent to Theo, June 1885

The Bridge at Langlois with Women Washing, March 1888
(detail; see page 131)

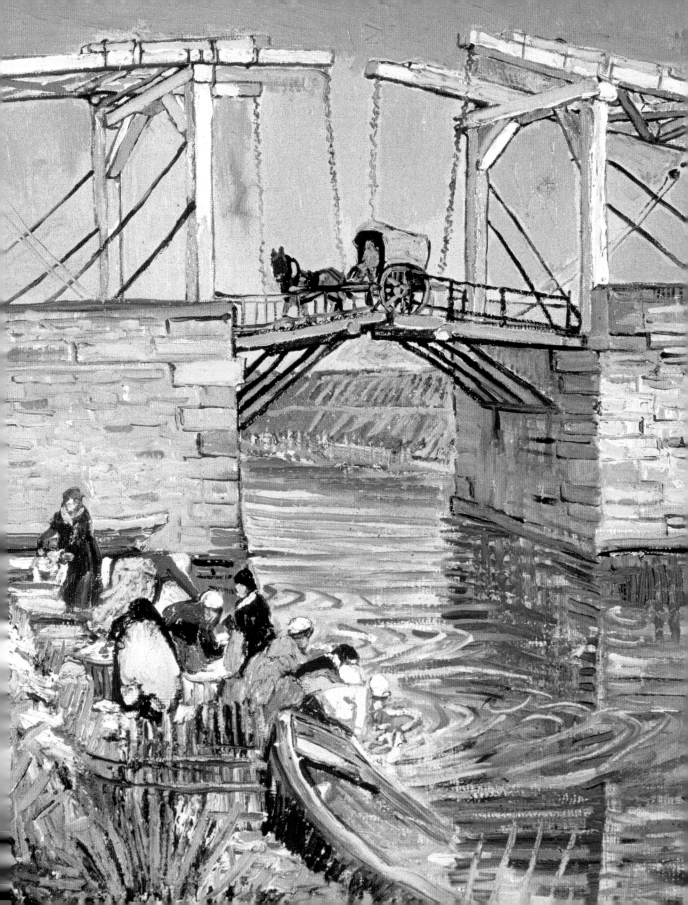

"But I must continue on the path I have taken now. If I don't do anything, if I don't study, if I don't go on seeking any longer, I am lost. Then woe is me."

The Painter on the Road to Tarascon, July 1888
(detail; see page 97)

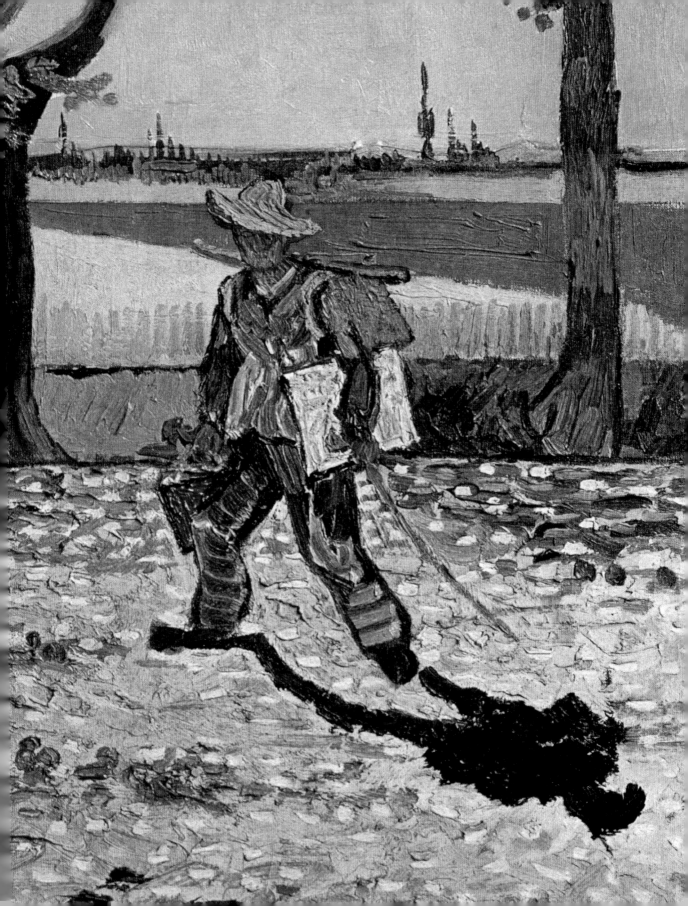

"They say – and I am very willing to believe it –
that it is difficult to know yourself – but it isn't easy
to paint yourself either."

Vincent to Theo, September 1889

Self-Portrait with Bandaged Ear, January 1889

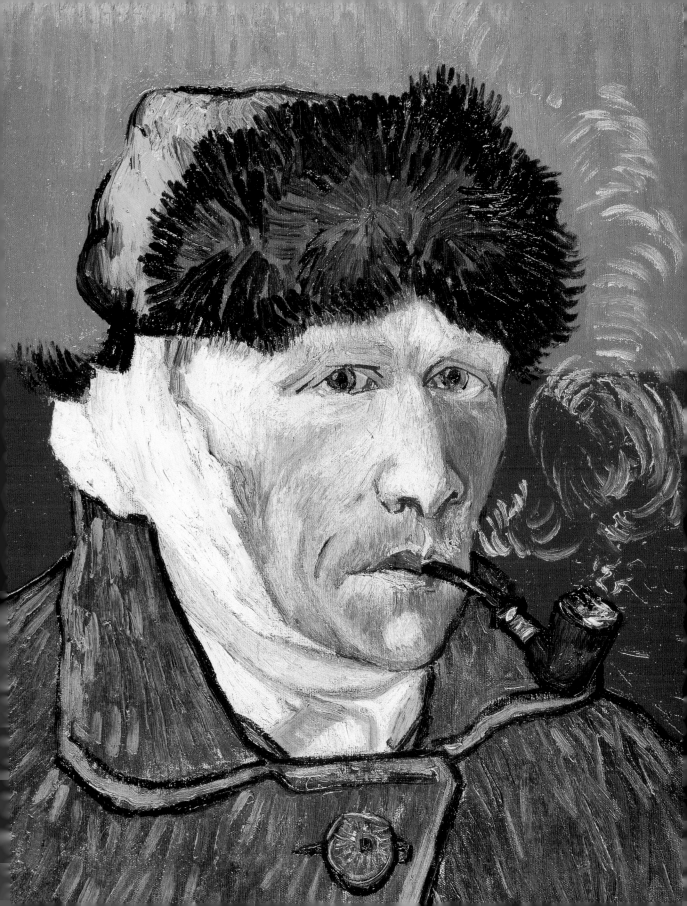

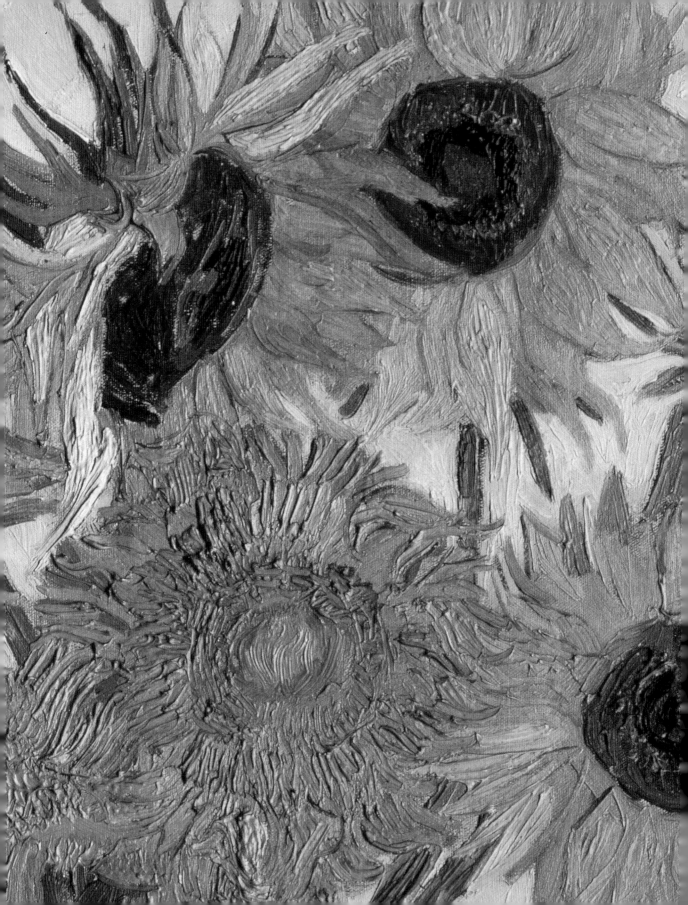

"I cannot help it that my pictures do not sell. Nevertheless the time will come when people will see that they are worth more than the price of the paint …"

Still-Life: Vase with Twelve Sunflowers, August 1888
(detail; see page 46)

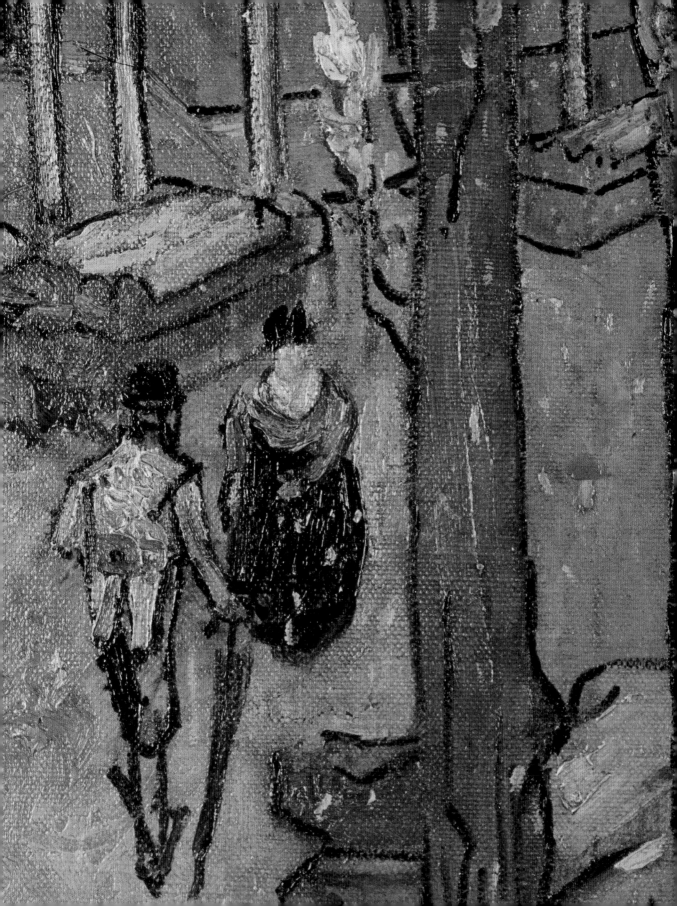

"… it's my constant hope that I am not working for myself alone. I believe in the absolute necessity of a new art of colour, of design and – of artistic life. And if we work in that faith, it seems to me there is a chance that we do not hope in vain."

Vincent to Theo, Arles, March 1888

Les Alyscamps: Falling Autumn Leaves, November 1888
(detail; see page 95)

"The more ugly, old, vicious, ill, poor I get, the more I want to take my revenge by producing brilliant colour, well arranged, resplendent."

Vincent to Wil, Arles, September 1888

Willows at Sunset, Autumn 1888
(detail; see page 131)

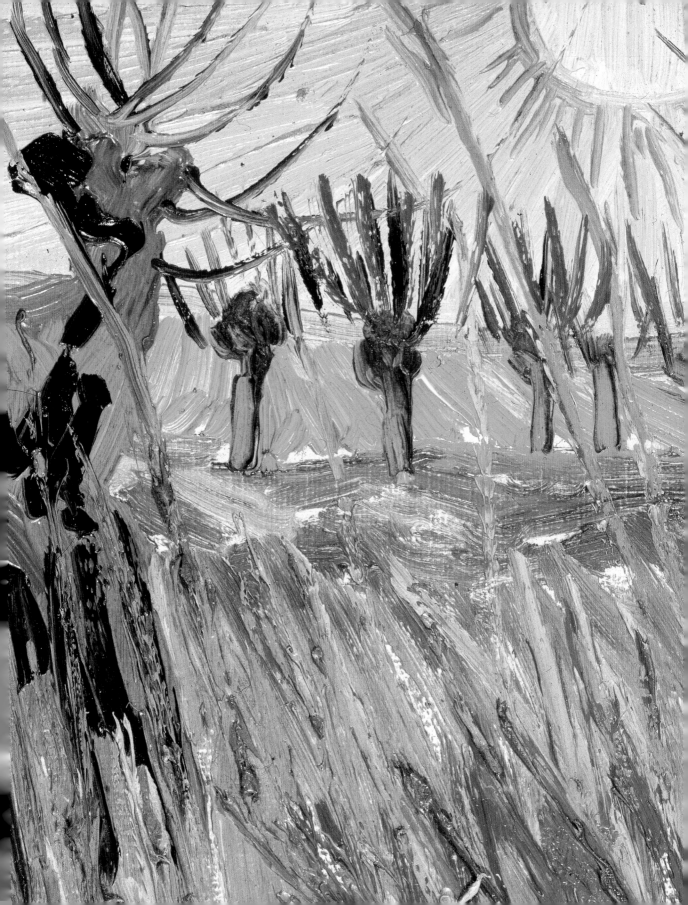

"I am a man of passion, capable of and subject to doing more or less foolish things, which I happen to repent, more or less, afterwards."

Vincent to Theo, 1879/80

The Dance Hall, late 1888
(detail; see page 131)

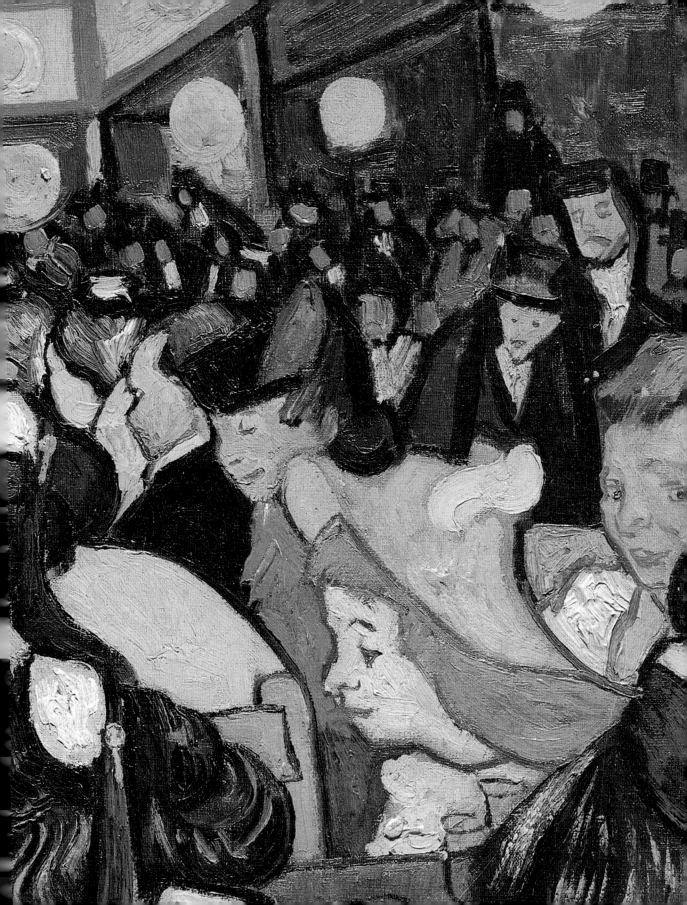

"But I find in my work an echo of what struck me, after all. I see that nature has told me something, has spoken to me, and that I have to put it down in shorthand. In my shorthand there may be words that cannot be deciphered, there may be mistakes or gaps; but there is something of what that wood or beach or figure has told me in it, and it is not the tame or conventional language derived from a studied manner or a system, but rather that from nature itself."

Vincent to Theo, autumn 1882

Woman on Tree-lined Road, December 1889
(detail; see page 133)

"And yet I see a light in the distance so clearly; if that light disappears now and then, it is generally my own fault."

Vincent to Theo on 5 July 1876

Harbour Workers in Arles, August 1888
(detail; see pages 70/71)

"But seeing that nothing opposes it – supposing that there are also lines and forms as well as colours on the other innumerable planets and suns – it would remain praiseworthy of us to maintain a certain serenity with regard to the possibilities of painting under superior and changed conditions of existence …"

Vincent to Bernard, Arles, June 1888

Starry Night (Cypresses and Village), June 1889
(detail; see page 133)

"In life it is the same as in drawing – one must sometimes act quickly and decisively, attack a thing with energy, trace the outlines as quickly as lightning."

Vincent to Theo on 11 May 1882

Fishing Boats on the Beach at Saintes-Marie, June 1888

"Colour expresses something in itself, one cannot do without this, one must use it; what is beautiful, really beautiful – is also correct."

Irises, May 1889
(detail; see page 99)

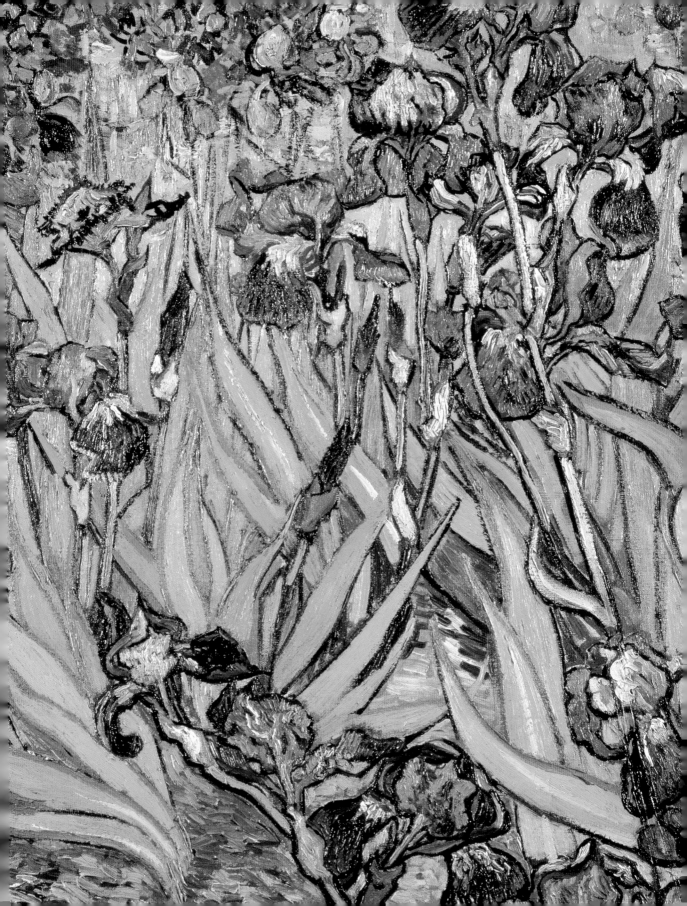

"In my opinion, I am often rich – not in money, but (though it doesn't happen every day) rich – because I have found in my work something which I can devote myself to heart and soul, and which inspires me and gives a meaning to life."

Vincent to Theo, March 1883

Still-Life with Onions and a Plate, January 1889
(detail; see page 112)

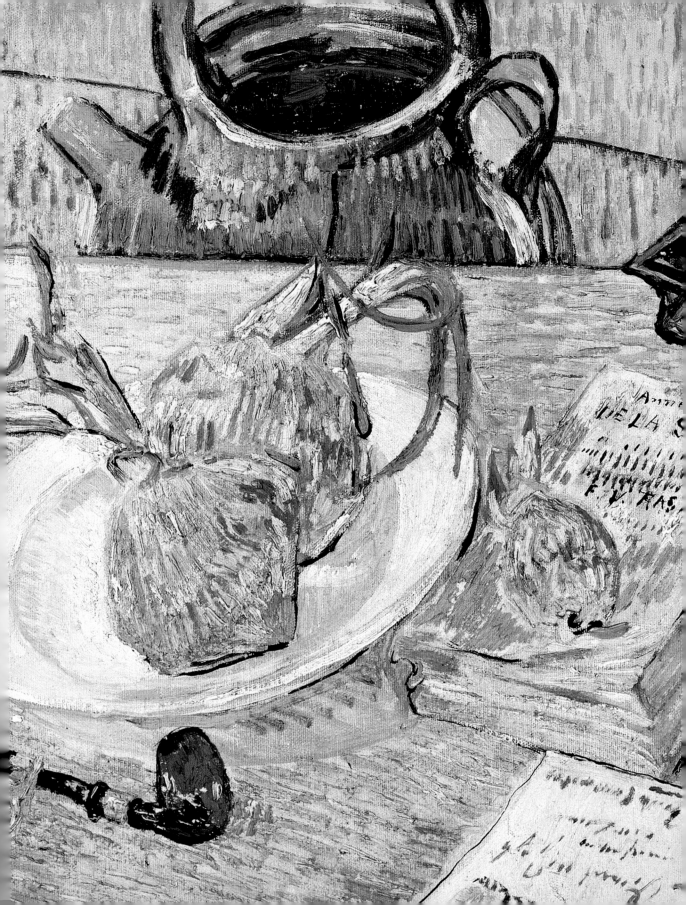

"They are vast fields of wheat under troubled skies, and I did not need to go out of my way to try to express sadness and extreme loneliness … since I almost think that these canvases will tell you what I cannot say in words, the health and restorative forces that I see in the countryside."

"Over those roofs one single star, but a beautiful, large, friendly one. And I thought of you all and of my own past years and of our home, and in me arose the words and the emotion: Keep me from being a son that maketh ashamed; give me Thy blessing, not because I deserve it, but for my mother's sake. Thou art love, encompass all things. Without Thy continued blessing we succeed in nothing."

Vincent to Theo on 31 May 1876

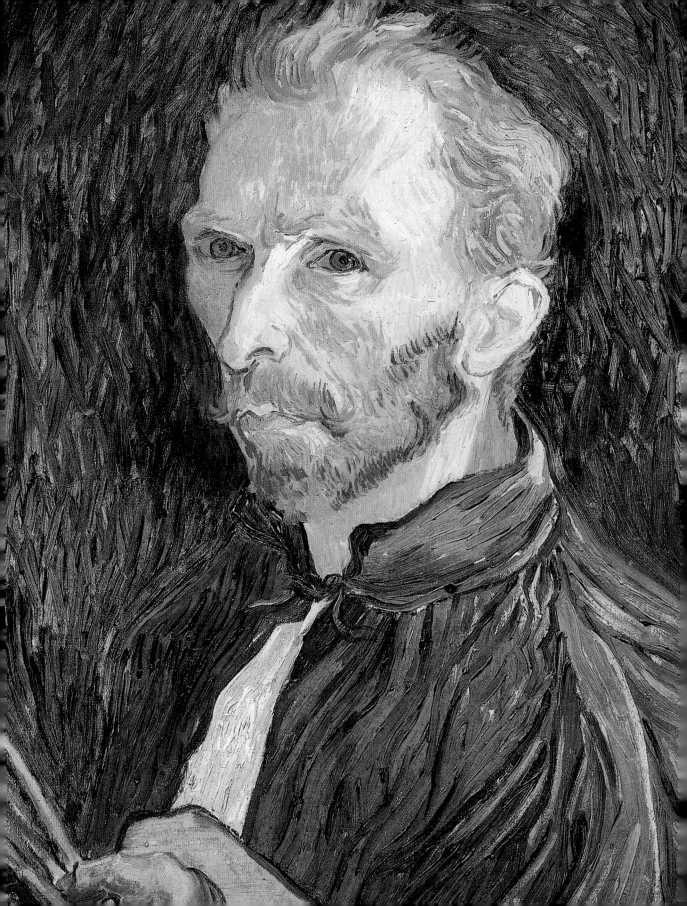

The Artist seen through his own Eyes

"Work has got me in its grip now, and I think forever, and though this is not something to be unhappy about, yet the mental picture I have of happiness is different."

Happiness is indeed a rare thing in the letters that Vincent van Gogh wrote to his family and friends. When, aged thirty-five, he reported on his work situation to his younger sister Wil, he had just moved to Provence a few weeks earlier and, although he had already produced hundreds of drawings and paintings, he felt that he was no closer to his goal. In Arles, he really would come to feel the embrace of art as, using brush and pen, he set about capturing the likeness of nature and those living in its midst.

Before moving south to Arles, he had been in Paris, the city he left "quite ill and almost addicted to drink." He was unsuited to such a life and was now convinced of something else: given that his nature put an end to any notions of starting a family, he made the point "that it's more worthwhile to work in flesh and blood itself than in paint or plaster, more worthwhile to make children than pictures or carry on business." But he lived "outside real life", as he wrote to Theo, his younger brother by four years, in the spring of 1888.

As Vincent stated repeatedly throughout almost twenty years of correspondence with his brother, Theo and he were making "the same journey as travelling companions." 'We' paint, 'we' hope in vain for a breakthrough, 'we' are often penniless and on many a black day 'we' lose faith that the road chosen is the right one. It is this 'we', his belief in solidarity with his younger brother, that kept van Gogh going, as did his belief later in an artists' association, an idea that eventually became something of an obsession.

Van Gogh, in fact, developed quite a few obsessions as he read, drew, painted and wrote letters. As the result of ten years of obsessive and frantic creative activity, the Dutchman produced more than 2,100 paintings and drawings. His artistic output is complemented by almost 900 letters, some of which are no less artistic in that many of them contain sketches of his work. Theo received the lion's share of these letters. Over a period of ten years, Theo supported his elder brother both morally and financially. Compared to Theo, Vincent turned out to be an almost compulsive letter writer who also kept his parents and younger sister posted. In letters to his friend Émile Bernard, he

Self-Portrait as an Artist, September 1889

During his time in Saint-Rémy, van Gogh viewed painting as a 'lightning conductor' for his illness. Between attacks, he painted furiously, initially convinced of the therapeutic effect of his art, but he also tried to reassure his brother, the recipient of the paintings.

Verleden week ben ik dagelyksch op 't veld
by den korenoogst geweest —
waarvan ik nog een compositie gemaakt
heb

Dat maakte ik voor iemand in Eindhoven
die eene eetzaal wenscht te decoreeren. Hy wilde
dat doen met composities van diverse heiligen
Ik gaf hem in bedenking of een 6 tal voorstellingen
uit het boerenleven van de Meyery — tevens de
4 jaargetyden symboliseerende — nul niet tota
niet meer den appetyt der brave menschen die
aldaar aan tafel moeten komen zitten zou
opwekken dan de mystieke personages hierboven
genoemd — Nu is de man daar warm op geworden
na een bezoek op 't atelier —
Maar hy wil zelf die vakken schilderen en
zou dat lukken ! (Doch il zou in reductie de composities ontwerpen)
in schilderen —
Dat 't is een man die ik zoo mogelyk wil te vriend
houden — een gewezen goudsmid die tot
3 maal toe een zeer aanzienlyke collectie
antiquiteiten heeft verzameld & verkocht —
Nu ryk is en een huis heeft gezet, dat

explained both his state of mind and his draft sketches but, after years of exchanging letters with him, van Gogh fell out with the man he called 'amice Rappard'. After their short-lived attempt at forming an artists' commune came to an abrupt end, van Gogh kept in touch with Paul Gauguin, describing to him in detail what he happened to be working on. He wrote copiously, even if "writing is only a poor means of making things clear to each other." Nevertheless, they gave him – a man who found it hard to approach others – an opportunity to exchange ideas and participate in life. When van Gogh's health increasingly deteriorated in his final years, letter-writing became therapeutic for him: it calmed him down between his frenzied bursts of activity and took his mind off his daily over-exertion: "I am writing this letter little by little in the intervals when I am tired of painting." He frequently made comments of this nature. Even when he withdrew to the psychiatric hospital at Saint-Rémy, van Gogh wrote in great detail about his plans, his health and his surroundings – only to sign off some of his letters rather dryly: "… I could tell you in two words what is in it: nothing new, but I can't go and write that again." He felt that mockery was less characteristic of himself than his absent-mindedness, that became more and more evident, especially in Arles. When yet another incorrectly addressed letter was returned to him, van Gogh was able to laugh at himself. He could also be poetically witty, even if often with a heavy heart, as in his digression on illness as a means of reaching the stars: "Just as we take the train to get to Tarascon or Rouen, we take death to reach a star. One thing undoubtedly is true in this reasoning is that we *cannot* get to a star while we are *alive*, any more than we can take the train when we are dead. So to me it seems possible that cholera, gravel, tuberculosis and cancer are the celestial means of locomotion, just as steamboats, buses and railways are the terrestrial means. To die quietly of old age would be to go there on foot."

Early on when Theo was only twenty-one, it was he who 'put solid ground' under Vincent's feet again – and who stuck by Vincent, even though over the next twelve years he would receive his fair share of what his brother called his 'yellow-soap or salt-water letters', the pages and pages he wrote during his fits of ill temper. In their conversations, the elder brother often felt inhibited, was curt and gruff with him. Even in his letters, his tone is often angry, imperious, unjust – and not only towards his brother. The letters contain brazen demands for more money, even if Theo would have to borrow it when hard up himself; urgent requests to get the landlord off Vincent's back; serious threats; financial talk about working capital and pensions. Van Gogh gave free reign to his moods when he was unable to survive on the money he had. Only rarely, however, did Theo lose his temper at his brother's rather exuberant lack of financial sense.

Unable to take criticism himself, van Gogh still demanded 'intellectual sincerity' from Theo, but often hit back immediately when his brother's criticism was negative. When Vincent did so, he was not sparing in his unambiguous and frequently harsh judgement of his family and fellow artists. Van Gogh even apologised in advance to his

Letter to Theo, early August 1884

Van Gogh's enthusiasm for art is evident from the sketches that he added between the lines of his letters or included on separate sheets after 1881. In summer 1884, when he was at home in Holland, he took the golden wheat fields as his theme and described the seasons in detail to Theo.

Letter to Theo, drawing on envelope,
March 1883

Van Gogh cannot resist drawing on an
envelope addressed to Theo in March
1883. He was trying to convince his
brother, who was actively supporting
him, that he was making progress as an
artist.

friend Anthon van Rappard just in case he should come in for some harsh criticism.
Theo criticised Vincent as his brother and as an artist, passed comment on his behav-
iour as well as his work, and even contributed to the occasional silences between them –
but he did not desert him. When his son was born at the beginning of 1889, he immedi-
ately posted a letter to Vincent: "As we told you at the time, we are going to name him
after you, and I devoutly hope that he will be able to be as persevering and as coura-
geous as you."

Not only letter-writing drove van Gogh to extremes; it was simply not in his nature
to do things by halves. When this late starter finally set out on the path to becoming a
painter, for years he refused to do anything other than copy earlier artists and draw from
nature, and time and again he diligently worked his way through his instruction manu-
als – even when his paper ran out.

Hardly any less enthusiastic, he spent years absorbed in the Bible, and later – no
less painstakingly and systematically – he worked his way through the novels of the
French Naturalists: Zola, Maupassant, Goncourt. He devoured them all, always in lively
exchange with Theo: "Books, reality and art are one and the same thing for me."

Almost always at odds with his – or rather Theo's – means, van Gogh developed
a fondness for collecting things that every once in a while prompted him to go on a

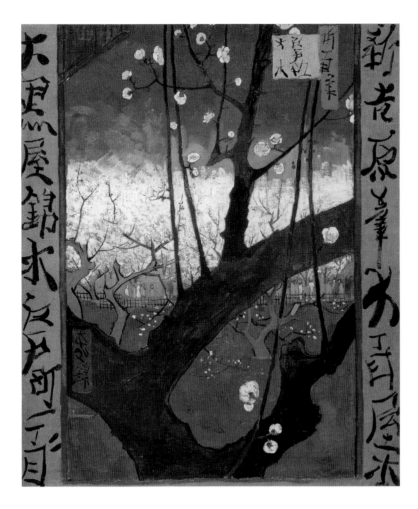

Flowering Plum Tree (after Hiroshige),
Summer 1887

spending spree. In 1889, he informed his brother that to continue studying he needed not just a few but "all the reproductions of Delacroix's pictures that are still available at that shop where they sell, I think at a franc apiece, lithographs after other artists, ancient and modern." By 1882, he had collected almost 1,000 woodcuts that were no less remarkable than his collection of Japanese prints. Barely able to stop himself writing, even on the items he had so eagerly collected, van Gogh at times released his pent-up energy by drawing along the sheet margins.

Van Gogh expressed his liking for Japanese art in his paintings in the style of Utagawa Hiroshige and Kesai Eisen. When living in Antwerp, he covered the walls of his room with 'crêpes' – just like Maupassant's Bel-Ami. In Paris, where Japanese crêpe prints were popular in Impressionist circles, he even considered dealing in them. In his usual acquisitive style, he purchased vast numbers of them, barely able to tear himself away from the shops where they were on sale. Not only were the Impressionists 'the Japanese of France', Provence was his Japan!

Van Gogh's road to becoming a painter could not take second place to such excesses. His examination of colour so completely preoccupied him for weeks on end that in his letters whole pages were covered in complementary colours. Just as the whole world was composed of nothing but Delacroix's colour theories when he was studying

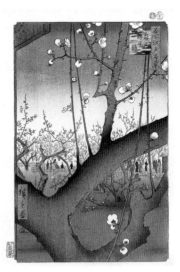

Hiroshige, **The Plum Garden at Kameido**,
1856

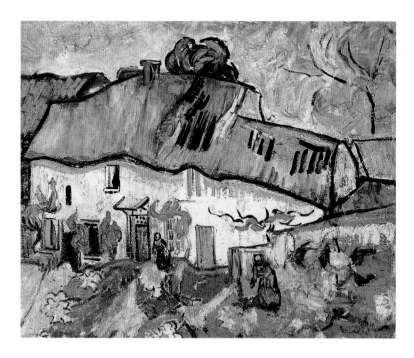

A Group of Cottages, May/June 1890

Opposite page
Self-Portrait in a Felt Hat, Spring 1886

In his first few months in Paris, van Gogh painted self-portraits to compensate for his lack of models. He spent a lot of time in his brother's apartment in front of the mirror and produced over twenty self-portraits.

them, van Gogh's short-term teacher Mauve was his one and all, with nothing and no one surpassing him.

Always dissatisfied and rarely happy with his work, he felt only a little of what he produced really worked; most of his works in oil he described as 'studies'. As if possessed, he produced prodigious numbers of pictures – in the two months he spent in Auvers around seventy paintings and thirty drawings alone.

Once something had entered van Gogh's head, he would not let it go. When his widowed cousin Kee became the object of his affections, he drove her whole family to despair with all his letters and visits – and presumably Theo, too, who was able, albeit a little later, to read all about it, down to the smallest detail. And yet the whole thing was quite simple really: "… it is my intention / To love her so long / Till she'll love me in the end."

When he turned his back on the art trade as a way to earn a living, and began instead to study the Bible, he felt "it has seemed to me that there are no professions in the world other than those of schoolmaster and clergyman." What Vincent then pulled off as a minister's assistant in the coal-mining and industrial region of the Borinage was no less zealous. He not only ran Bible study classes and, possessed by self-sacrifice, tended the sick, but gradually gave away all his belongings until – in sackcloth and ashes, and dirtier than the miners around him – he ended up living in a hut.

It is little wonder, then, that even as a young man, van Gogh complained about sleeplessness, head and toothaches, an upset stomach, nervousness, emotional turmoil, panic attacks and nightmares. Stacks of letters and paintings testify to his phenomenal rate of work. Keeping Theo informed about his thoroughly unhealthy lifestyle, Vincent would often describe his meals to him – not always without a hint of reproach. Writing from Antwerp, he states that since the 1 May (he was writing in February of the following year) he had "not had a hot dinner more than perhaps six or seven times." It was not that Theo had not sent him any money; Vincent had just preferred to use it to pay his models. It is little wonder that Antwerp marks the first low point in the artist's health: he was at risk of losing ten of his teeth and he smoked to dull his hunger. In Provence, too, he paid little heed to his basic needs. At one point in Arles, he spent five days living

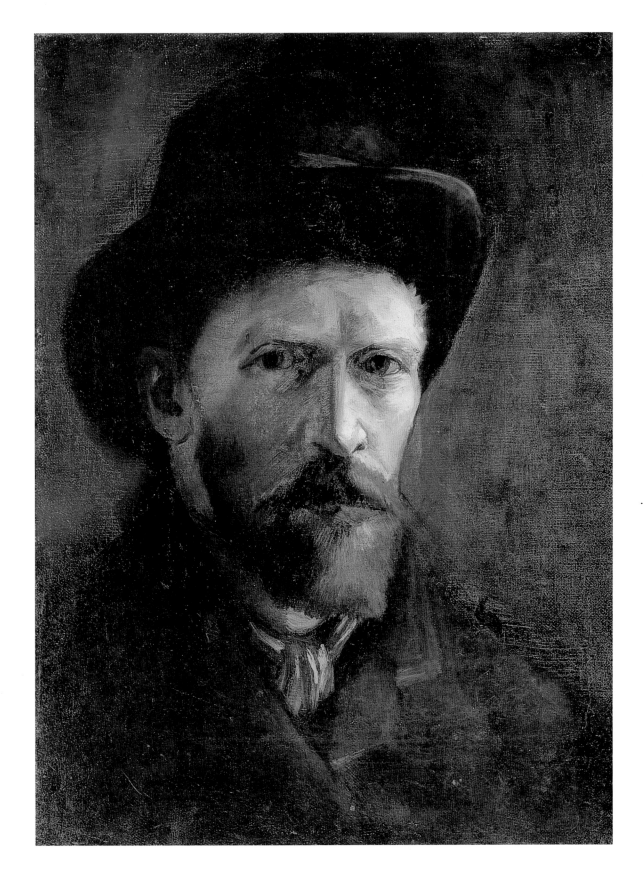

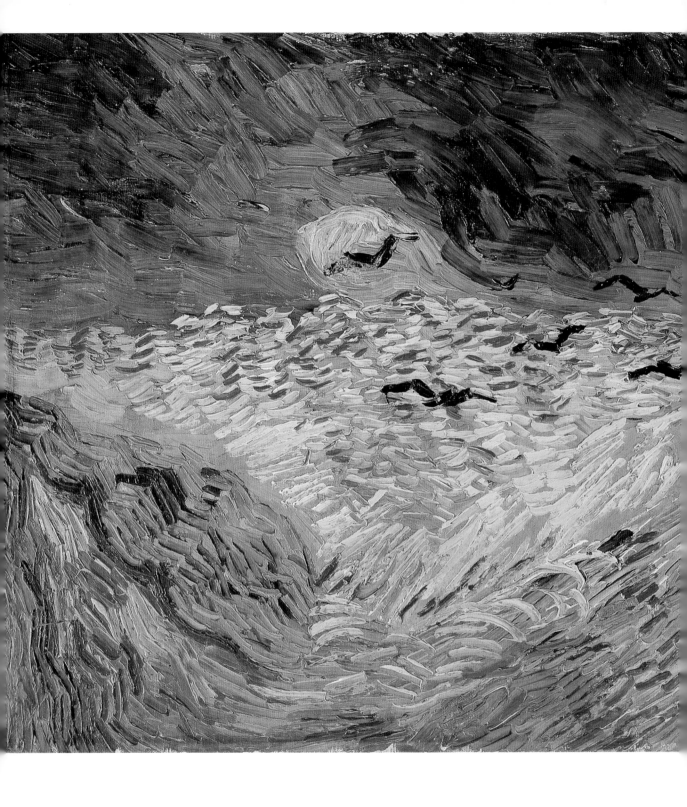

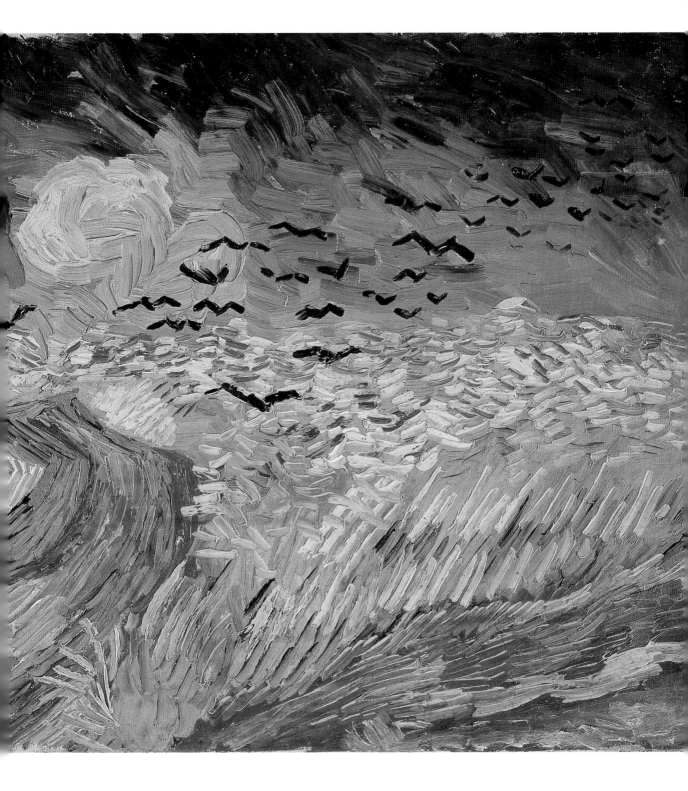

Crows in a Wheatfield, July 1890

Crows in a Wheatfield belongs to a series of large landscapes that van Gogh produced in the last weeks of his life in Auvers-sur-Oise. While Theo was happily embarking on family life in Paris, his brother roamed the wide, empty expanse of the surrounding countryside.

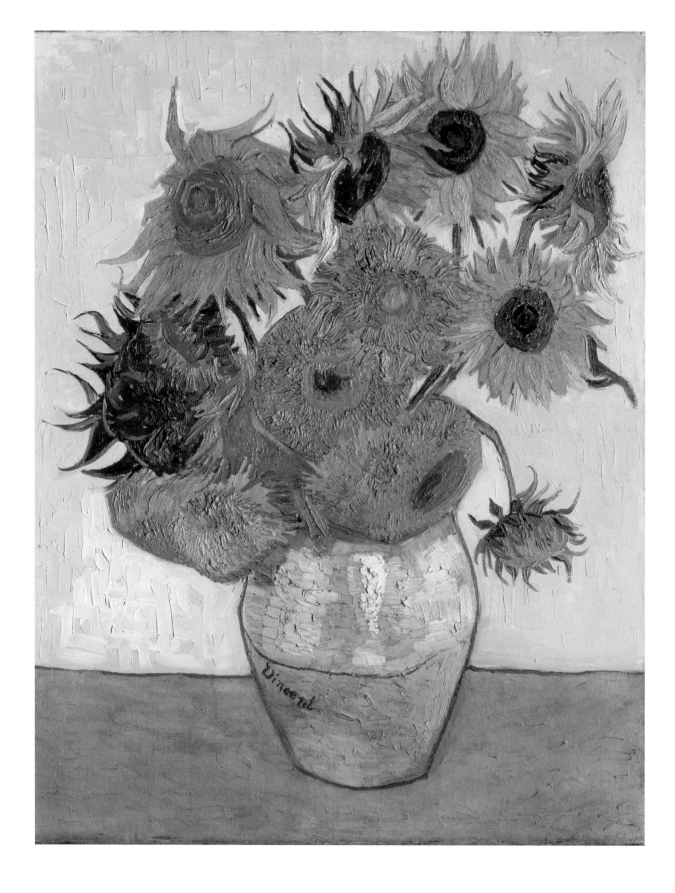

"mainly on twenty-three cups of coffee and bread." These courses of 'treatment' were not solely responsible for the delusions from which he began to suffer in the south of France, but there is no doubt that they were of little benefit to his constitution. Whether there is more truth in the theory that it was syphilis, epilepsy, mental strain, excessive consumption of absinthe or problems with his neurotic development, remains to be clarified, but what is certain is that van Gogh suffered for years from fits that alternated with lengthy phases of complete lucidity. His attempts at poisoning himself with paraffin oil or paint during his convulsive attacks failed.

When he experienced no improvement after finally removing himself from what he came to regard as Provence's dangerous sun, van Gogh put an end to his life in the north of France, even though there were no further indications of the sudden madness readily associated with him. Even at the outset of his career, he was fully aware of the hardships he faced: "The requirements are so great that at present painting seems like a military campaign, like a battle or war."

Myths and legends about van Gogh's life and work abounded shortly after his death. He was a lone wolf whose calls for artist friends went unheeded somewhere between dusty Brabant and the glaring sunlight of Provence; he was a misunderstood genius driven to madness by adverse circumstances. Such images about him still persist today. After all, they go so well with his work, starting – preferably at the end – with *Wheatfield with Crows*, a painting of deep foreboding that is presumed to be his last major work. Van Gogh's short life has been the stuff of novels and screenplays; his pictures are found on coffee mugs and umbrellas. Devoid of success during his lifetime, here is an artist whose work is somehow familiar to everyone today and who, after his death, achieved a hitherto unknown degree of fame in the art world. Record sums for a madman's sunflowers have regularly amazed us all and have only helped to distort the artist's image still further. Is there any room for him among the appealing myths that the present is so mindful of cultivating? For a number of years, the popular image of the artist has slowly been changing, with a new figure gradually coming into view: 'I, van Gogh' – the artist seen through his own eyes.

Still Life: Vase with Twelve Sunflowers, August 1888

The colour yellow in the Mediterranean sun deeply impressed van Gogh. Before Paul Gauguin's long-awaited arrival in Arles, he enthusiastically spent time on a decorative scheme – 'a symphony in blue and yellow' – for the house they would share. Van Gogh painted faster than ever before to capture the splendour of the sunflowers before they started to wilt.

Mon cher Theo Bien merci de la lettre qui m'a
fait bien plaisir arrivant tout juste au moment
où j'étais encore abruti par le soleil et la
tension de mener une assez grande toile
J'ai un nouveau dessin d'un jardin plein
de fleurs, j'en ai également deux études
peintes

Je dois t'envoyer une nouvelle commande
de toiles et de couleurs assez importante
Seulement elle n'est point pressée
Ce qu'à la rigueur serait pressé serait plutôt
la toile vu que j'ai un tas ~~d'études~~ de chassis
dont j'ai détaché les études et où entre temps
je dois remettre d'autres toiles.

ciel bleu vert maisons
blanches à toits rouges cyprès noir
laurier rose et figuier
tournesols

bande blanc et jaune citron
bande violette
bande Orangé et vert
bleu et vert jaune

à gauche fleurs rouges à droite
vigne

A Letter-Writer
and his Brother

Vincent's earliest exchange of letters with Theo was in August 1872. His younger brother often meant the world to him and it was to him that the artist addressed his very last letter. On some days, Vincent posted two letters to Theo, such as in April 1882 when he needed to clarify an important issue: "And what am I? Only a man who has difficult, trying work to do, for which he needs peace and quiet and some sympathy; otherwise the work is impossible."

Van Gogh's handwriting varies between the fastidiously neat and the utterly chaotic, and he also flits back and forth from one language to another. Even as a young man, van Gogh had a good command of English and French besides his mother tongue. In the heat of the moment – both in his letters and during conversations – he also resorted to his excellent Esperanto. He wrote the majority of his letters in Dutch, but in Arles he switched to French; some of his letters to Theo he also wrote in English. He underlined some things, scored other things out, signed off in between and picked up where he left off. He rarely used pencil, preferring instead to fill both sides of his cheap paper with ink.

Especially during the early years of their correspondence, an over eager van Gogh, who was equally lacking in moderation with regard to the Bible, would copy out pages and pages of theological explanations, quotations from the Bible and even whole hymnbooks for the edification of his brother and friends.

In the early days, the voice of big brother – at times older than his years – comes across in van Gogh's letters. He recommends books for Theo to read, foremost among them his beloved Zola whose works he described as 'healthy fare'. He is eager to guide Theo in his art education, and advises him on all manner of things ranging from the benefits of being a regular gallery-goer to medical advice: "Theo, again I urge you to smoke

Opposite page
Letter to Theo, 19 July 1888

Garden with Flowers, July 1888

Avez vous aussi vu les oliviers? Maintenant j'ai un portrait du D.r Gachet à expression navrée de notre temps. Si vous voulez quelque chose comme vous disiez de votre christ au jardin des oliviers pas destiné à être compris mais enfin là jusque là je vous suis et mon père sait et bien cette nuance.

J'ai encore de là bas un cyprès avec une étoile un dernier essai – un ciel de nuit avec une lune sans éclat à peine le croissant mince émergeant de l'ombre projetée opaque de la terre – une étoile à éclat exagéré, si vous voulez, éclat doux de rose et vert dans le ciel outremer où courent des nuages. En bas une route bordée de hautes cannes derrière lesquelles les alpines bleues une vieille auberge et un très haut cyprès tout droit tout sombre.

Sur la route une voiture jaune attelée d'un cheval blanc et deux promeneurs attardés. Très romantique si vous voulez mais aussi je crois de la Provence. Probablement je graverai à l'eau fort celle là et d'autres paysages et motifs souvenirs de Provence alors je me ferai une fête de vous en donner un tout un résumé un peu voulu et étudié. Mon père dit que Lauzet qui fait les lithographies d'après Monticelli a trouvé bien la tête d'arlésienne en question

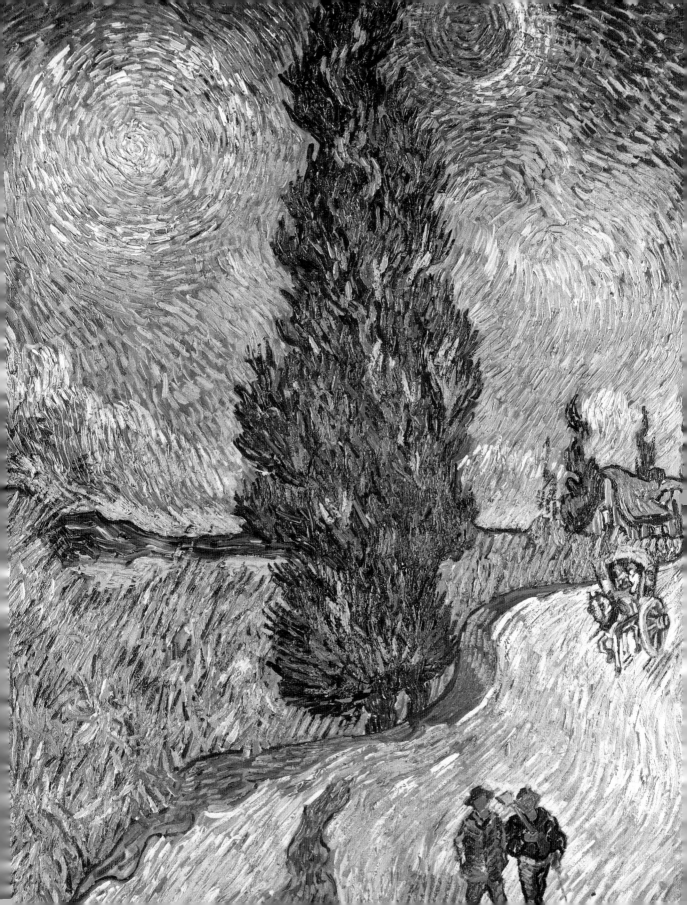

Previous pages
Letter to Gauguin from Auvers-sur-Oise,
c. 17 June 1890

**Road with Men Walking, Carriage,
Cypress, Star and Crescent Moon**, May
1890

About a month after painting this pic-
ture, van Gogh described it in detail and
added a sketch of it for Gauguin. The
painting was still in Saint-Rémy, which
explains why van Gogh had to describe
it from memory: "Very romantic, if you
like, but I also think it very characteristic
of Provence."

Theo van Gogh, *c.* 1888

Opposite page
Père Tanguy, Winter 1887/88

Two Paris art dealers who not only
shared a love of Impressionism but who
also supported van Gogh as best they
could. Theo gave his brother a home and
Julien 'Père' Tanguy accepted Vincent's
paintings as payment for his materials.

a pipe, it is *so* good if ever you feel troubled." Van Gogh is not least an expert in matters of the heart, and he shares with Theo the details of his own – generally unsuccessful – affairs, but often when it is already too late in terms of bourgeois convention. The correspondence contains the changing views of both brothers about their favourite artists, pictures, exhibitions and museums, all neatly listed. Not infrequently, stacks of prints found their way across the Continent – in both directions. And when van Gogh was penniless and felt isolated in the Borinage mining district or in Drenthe, it fell to Theo to supply him with aesthetic surroundings by describing paintings to him, sending him magazines and prints and keeping him up-to-date about the latest trends on the art scene in Paris and the city's annual salons: "Here, of course, I never see anything, and I do occasionally need to see something of beauty …" In this way, Vincent informed Theo in December 1882, that the latter could make amends for the long periods in which he did not write: "Write again if you can, but if you are too busy, I'll understand perfectly, and then you will make up for it later by a few descriptions of Montmartre."

Edited, if not to say censored, by Theo's wife Johanna, the odd profanity did find its way into Theo's letters, as did such mundane items as chocolate or tobacco and the odd item of clothing for van Gogh. And, in the midst of such correspondence, there are poetic descriptions by van Gogh himself of the empty Dutch moors in which "fantastic silhouettes of Don Quixote-like mills or curious giants of drawbridges stand out against the shimmering evening sky."

When, aged twenty-seven, van Gogh made the decision to become an artist, his relationship with his brother changed and their letters acquired greater significance. "But now I am working at full speed – my painting must progress with all the energy we can bring to it." We? The plural form was first used by van Gogh in his letters after he had decided to become an artist, very probably following an earlier suggestion made by his brother. Starting in 1880, Theo began to provide for his older brother, sending him money for food and rent from Paris, as well as canvases, paint, paper and brushes. Yet he gave the artist, who often felt isolated, far more: "Do write to me, my boy, even if you have no money, for I need your sympathy; it is no less a support to me than your money." For many years, Theo was the sole confidant accepted by van Gogh, whose long letters gave his brother insights into the creative process. Even when he quarrelled with the rest of his family, who were opposed to him living with a prostitute, Vincent's thoughts were always with Theo. When he wrote to him, his inner turmoil lessened: "Things become a little clearer, I ponder this way and that, and things fall into place and acquire form." It was only thanks to Theo that van Gogh did not lose contact with his family altogether. When he had to spend a few weeks in hospital in The Hague, his parents – notified by Theo – sent him parcels, and his father even paid him a visit. What counted most, however, was word from his brother: "… for I assure you, a warm letter from you does me more good than any of my pills."

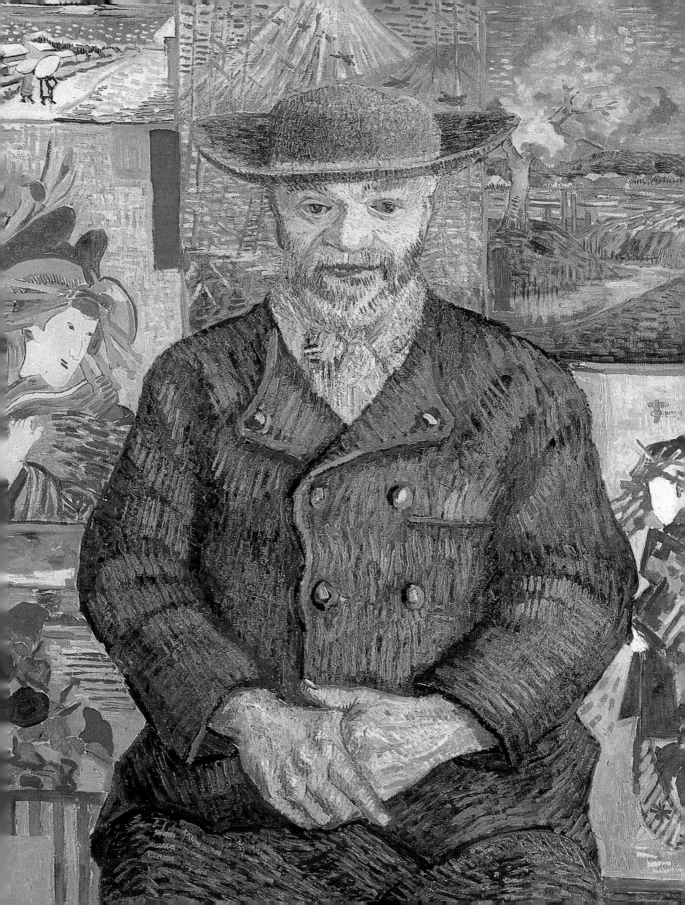

His brother's regular payments pricked van Gogh's bad conscience, something that – besides his gratitude – found frequent expression in his letters. Even as a self-taught artist, he must be able to sell *something*; even he was worth his salt and deserved the day's wages of an honest worker. On bad days, though, van Gogh even rues ever picking up a paintbrush or a pencil. Then, on one of his good days, he exclaimed "It is almost miraculous" after an uncle had commissioned him to do a series of pen drawings. One swallow does not make a summer, of course, and Theo's praise, encouragement and interest became all the more important. Van Gogh's words show that he missed his brother and their discussions about art, his knowledge of the art trade and – time and again – how grateful he was to his brother: "… your help was a kind of fence or shield between a hostile world and myself, and because I could in all calmness think almost exclusively of my drawing, and my thoughts were not crushed by fatally overwhelming material cares." van Gogh had his own peculiar way of coping with financial worries. In the summer of 1883, he informed Theo that, on the one hand, he was about to be repossessed, yet, on the other, he was lighting his pipe using the tax assessors' reminders! "You're some businessman …" was as much criticism as he heard from Theo who then paid off Vincent's creditors in various places. Vincent could not even get by on his monthly allowance; any delay in his brother's postal order caused him to react with dismay, desperation, anger and sometimes even brazen demands for yet more money – "*now!*"

Although they should have been able to treat each other 'franchement', when Theo did openly criticise his older brother's work, Vincent thundered back no less plainly: "You haven't yet sold *one single piece by me* – whether for a lot or a little – and in fact you haven't even *tried*." In his frustration and worry about failed relationships and hastily ditched careers, he liked to tar everyone with the same brush, as he did when he went back home to live with his parents again at the age of thirty. Not only Theo was unable to conceal his lack of understanding; Vincent felt his parents "feel the same dread of taking me in the house as they would about taking a big untrained dog," a role which he mockingly adopted. Theo took his parents' side and by return of post was asked by Vincent to stop his payments to him. In the postscript, van Gogh addresses his brother more than 'franchement': "You cannot give me a *wife*, you cannot give me a *child*, you cannot give me *work*; money, yes – but what good is it to me if I have to forgo the rest?"

With his last source of support in the family apparently disappearing, van Gogh hit out around him and destroyed everything that got in his way. Nonetheless, stubborn or not, he allowed his parents' laundry to be turned into a studio for him – and was then happy to accept his brother's next postal order. Van Gogh then considered himself an artist, and wanted his arrangement with Theo to be understood in that light. Over the course of a number of letters, the two of them bandied words back and forth and, at the

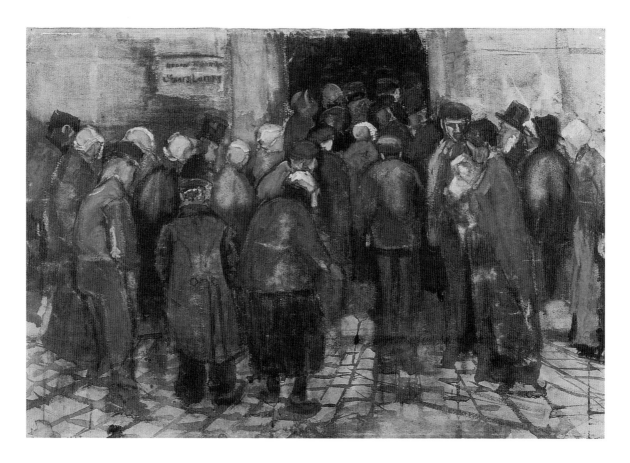

beginning of summer 1884, reached an agreement: van Gogh would sell his paintings to his brother, whose payment was intended to be only for those paintings he received. From that moment onwards and at irregular intervals, large and small parcels and rolled-up drawings and oil paintings made their way to Paris, the postage on occasion paid for by Theo. He really would be the one to suffer if he had no success selling his brother's work and, as van Gogh readily admitted, would carry the blame for the failings of all the incompetent and indifferent art dealers: "*My* sneers are bullets, not aimed at you who are my brother, but in general at the party to which you belong once and for all." In Antwerp, where van Gogh attended art school for a while and was entranced by the supposed ease of being a successful portrait painter, "the monthly allowance is too small for me to possibly make ends meet." Now the man about town, he must be frank: he needs a new suit to make himself presentable in public. And then, only three sentences further down the page, Vincent thanks his brother for a book he had sent and admits that Theo himself is thrifty.

Nevertheless, Theo tried to see Vincent, the artist, and Vincent, with his problems and worries, as separate entities, even when, in his time in Antwerp, an old dispute again raised its head, and van Gogh – already losing weight – considered "starting all my figure studies from the beginning again." "Do not think this the longer route; it is the shorter one. What to say to a man who so obviously and touchingly sees himself utterly at the mercy of someone else? You know my situation and know that my life or death depends on your help."

The State Lottery Office, September 1882

"It is often that way with almost all groups of figures: one must sometimes think it over before one understands what it all means. The curiosity and the illusion about the lottery seem more or less childish to us – but it becomes serious when one thinks of the contrast of misery and that kind of forlorn effort of the poor wretches to try to save themselves by buying a lottery ticket ..." is how van Gogh described the subject of his large watercolour to his brother.

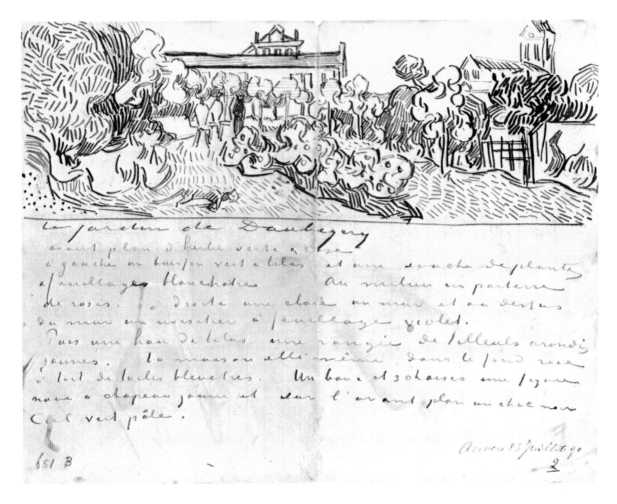

Letter to Theo, Auvers-sur-Oise, 23 July 1890

Van Gogh was not the only person to benefit from Theo's lack of egoism – a weakness of character that the younger brother incidentally saw in his older sibling and for which he reproached him. At times, Theo's limited salary helped provide for his brother, a sick relative, a cousin who had emigrated to India, "directly or indirectly … no fewer than six people." Van Gogh politely pointed out that he is first in the queue of illustrious recipients and also that with so little money he can only work at 'half speed': "It means my model, my studio and bread; economies mean something like suffocation or drowning …" It's not that he does not send Theo detailed, brief statements of his cash-flow: "In terms of ready cash, I currently possess a coupon for 1.23? francs – and I've already broken into it …"

From 1881 onwards, the letters are the most important source of biographical information there is about the 'melancholic' Vincent and the 'lucky fellow' Theo.

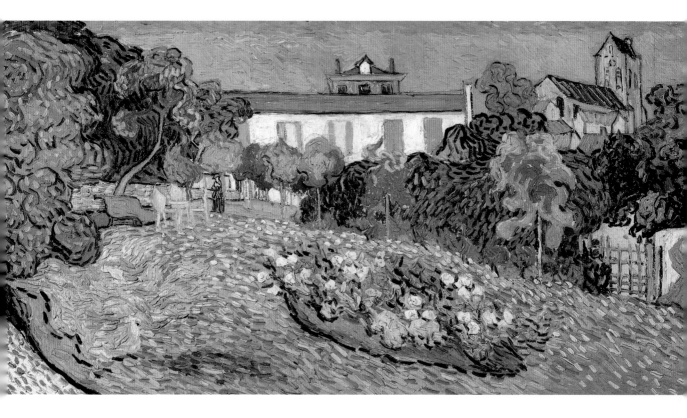

Daubigny's Garden, July 1890

A week before his death, van Gogh described two new paintings to his brother, one of them being *Daubigny's Garden*. He sent Theo a detailed sketch of it and felt it was one of his most powerful works.

Whether illustrated or not, their significance as commentaries on van Gogh's work cannot be overrated. Visually, his pages alternate between pure chaos and meticulous planning, as if he were putting down his sketches and words on expensive canvas rather than notepaper. In his letters, van Gogh draws landscapes with the same conscientiousness he applied to figure studies. Sometimes he sent Theo his *krabbels* – his 'scribbles', as he himself described most of his sketches – on individual sheets; the majority of them are inserted between and beside the lines of his letters, however. If lack of time prevented van Gogh from drawing a detailed sketch, Theo had to content himself with a few hastily drawn lines. The sketches in the letters kept Theo informed about van Gogh's progress as an artist. Whether new motifs or technical digressions, they were all intended "so that you may know I am working heart and soul on it to get a good and useful result." Sketches of the watercolours on which van Gogh worked in the summer of 1882 are also found in his letters. The subject of saleability crops up again and again. A number of sketches are intended to test whether or not his work is suitable for the marketplace: "Just tell me why they don't sell and how I might make them saleable." When van Gogh started work on his first large oil painting, he explicitly asked his brother to show his sketches of it around Paris. Potential buyers, after all, would be keen to hear about it.

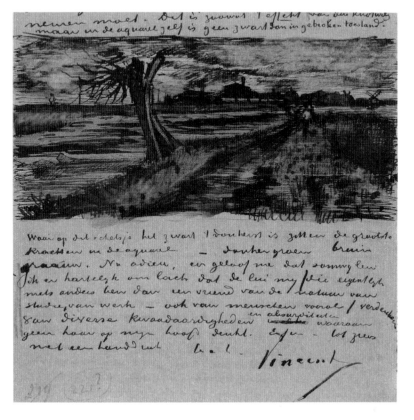

Letter to Theo, August 1882

In summer 1882, van Gogh began to use watercolours in addition to ink. Full of enthusiasm, he sent his brother his first drawings in the new medium.

Opposite page
Letter to Theo, 3 October 1883

Following pages
Olive Trees in a Mountain Landscape, June 1889

In June 1889, shortly after being admitted to the asylum at Saint-Rémy, the surrounding olive groves became van Gogh's preferred motif. Despite the fierce summer temperatures, he painted out of doors. His short, energetic brushstrokes suggest the shimmering heat of the countryside.

Spending the bleak autumn months of 1883 in the solitude of Drenthe, Vincent tried to convince both himself and Theo that the surrounding moors provided motifs en masse. At the beginning of October, he sent six pen drawings to his brother and tried to convince him to leave the art trade to become a painter instead.

The sketches in his letters from the south of France, addressed to Theo and his friends and colleagues in Paris – Émile Bernard, Paul Gauguin, John Russell – are characterised by a freer hand. The sketches in his letters also often reveal his liking for reed pen drawings. Unlike his short-lived watercolour phase, he no longer coloured his drawings, but instead only wrote the names of the shades he would later use, and would often specify the dimensions of his canvases. Van Gogh also documented his new surroundings: he produced a sketch of his bedroom in the Yellow House at Arles, as well as another drawing of the house and its surroundings, both based on his completed oil paintings. Much less often, van Gogh's letters included sketches of the portraits he produced at Arles, although they were close to his heart. He produced relatively few drawings in the last few months of his life, probably because he had neither the time nor the energy to do so given the incredible amount of oil paintings he produced during this particular creative phase. There was no more time to lose; he had so many plans for paintings in his mind's eye, and besides, the pictures Vincent sent Theo often gave him a better idea of how his brother was faring.

The tenor of his letters remained clear to the last, even if they contained fewer illustrations: Theo and he were the joint authors of his work "because the money from you, which I know costs you trouble enough to get for me, gives you the right, if there is some good in my work, to consider half of it your own creation."

Theo, for his part, did not only produce painting 'indirectly', as van Gogh put it, but was also an author in his own right. He appears to have had less of a need than van Gogh to communicate with others and only a small number of Theo's letters survive.

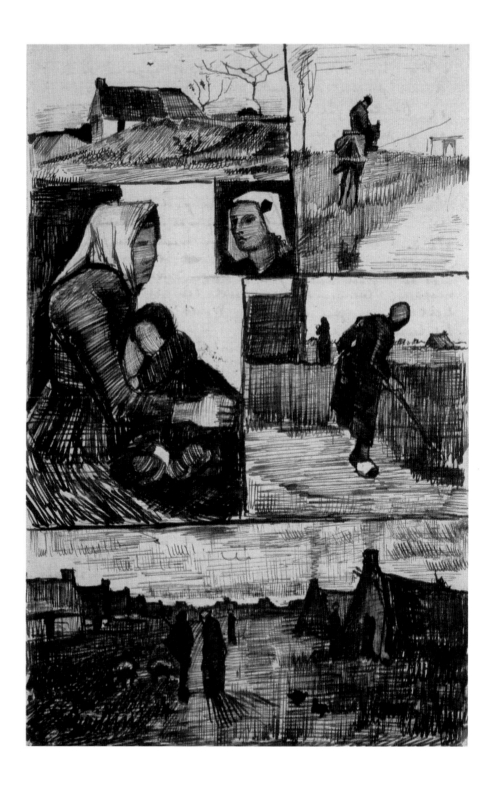

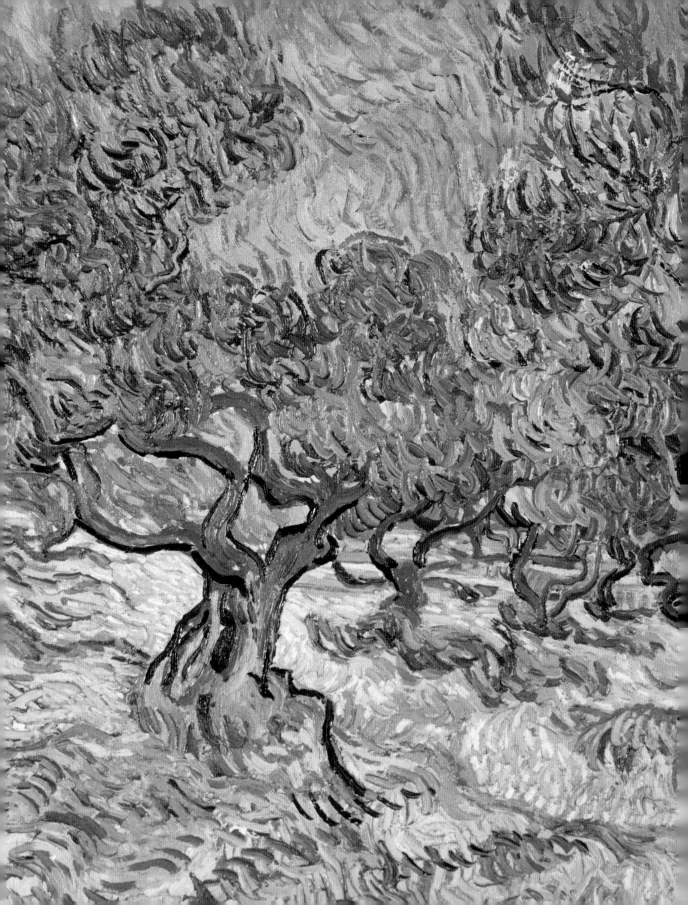

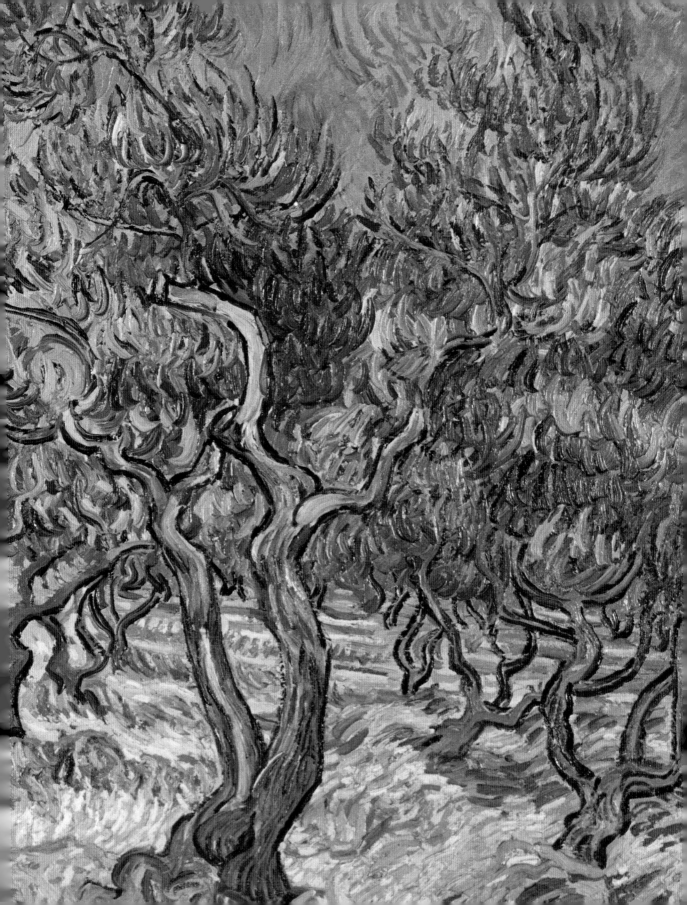

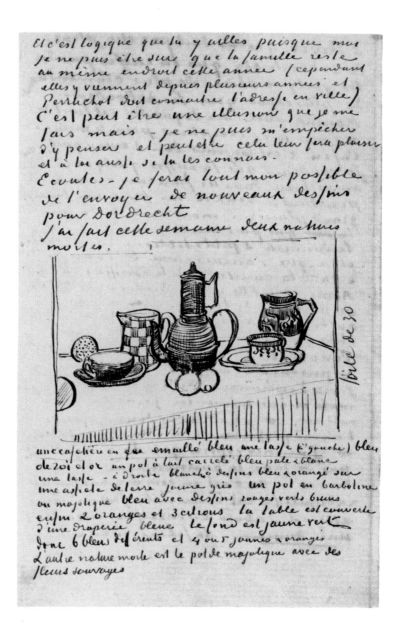

Letter to Theo, *c.* 20 May 1888, from Arles

Vincent, in fact, remonstrated with him for bottling up inside him his 'grandes et petites misères de la vie humaine' more than anyone else. But Vincent's replies and references themselves often speak volumes. When van Gogh's enthusiasm for Delacroix's theory of colour poured out over pages and pages, Theo, prompted by a Manet study, discussed the colour black in one of his letters. Already convinced about the 'art of words', van Gogh enthused: "And the whole letter proves to me exactly what I thought in Paris about your sketches, that if you took it up, you could paint with words." Theo's 'painted' criticism was also what Vincent was most ready to believe – and forgive. For years, Vincent did not trust his own eyes, and viewed his brother as his most important critic. Van Gogh not only presented his pictures to his brother for appraisal; Theo also had to read and approve several drafts of van Gogh's business and personal correspondence before it was sent off. All too often, his tone had been wide off the mark – once bitten, twice shy.

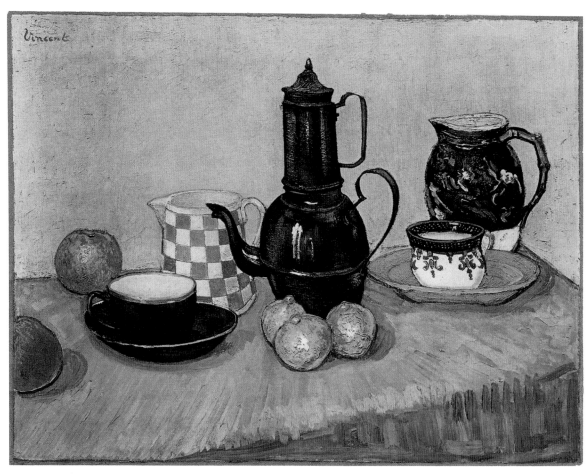

Still-Life with Coffee Pot, May 1888

Van Gogh gave a detailed description of his *Still-Life with Coffee Pot* to Theo and his artist friend Émile Bernard. He jotted down his colours in a sketch in Bernard's letter, and in the right-hand margin, he told Theo about the dimensions of his canvas.

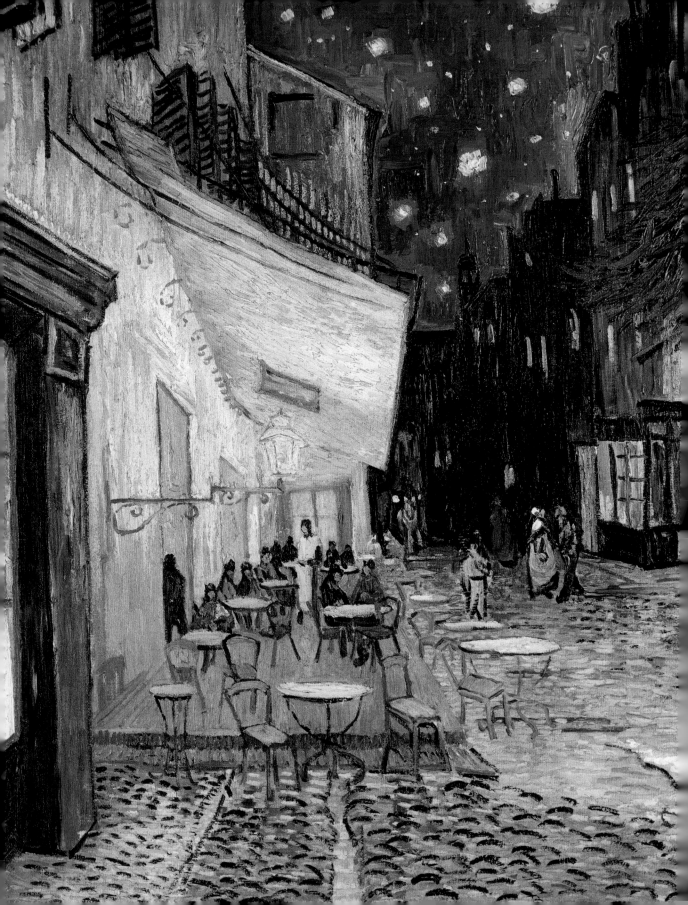

When Theo considered putting the art trade behind him, his consideration for his brother's paintings inevitably became less: "You do understand that it would be a burden to me if I were the reason that forced you into having to earn money." The older brother suffered even more when things did not go well for Theo, when, for months on end, Theo, too, had to struggle with the consequences of Vincent's dissolute life: "And I accuse myself of upsetting you too – with my continual need of money."

When in Arles and Saint-Rémy, van Gogh also wrote to his little sister Wil (Wilhelmina), while contact with his other siblings remained irregular. In his letters to Wil, a new trait in the artist becomes apparent: her big brother can use words quite cleverly and is sarcastic 'to a T'. Even at the point when his health is more than a little shaky, when he is 'sinking in melancholy', he gives a dryly amusing account of his preferred medicine: "Nevertheless, I am in the habit of taking large quantities of bad coffee in such cases, not because my strong imaginative powers enable me to have a devout faith – worthy of an idolator or a Christian or a cannibal – under the exhilarating influence of said fluid. Fortunately for my fellow creatures I have until today refrained from recommending this and similar remedies as efficacious."

Above all else, however, he reflects soberly on his own situation, taking stock in the summer of 1888, aged thirty-three: "You see what I have achieved: my work; and you also see what I have not achieved: everything else that goes with life."

The letters to Wil lack the drama and self-pity of his 'wicked, wasted youth', his lack of money and other things that Vincent occasionally succumbs to in his letters to Theo, although even he gets the odd glimpse of van Gogh's wit, such as when he comments on the fact that his brother had not bothered to write: "Not to write is good, but to write seasonably is not bad either; in some cases it is even much better."

The Café Terrace on the Place du Forum, Arles, at Night, September 1888

Van Gogh also wrote letters to his younger sister Wil. Besides brotherly advice, they contain his thoughts on painting. He described his café terrace beneath the night sky as a 'night scene without black'. It was painted at night *in situ*. "Of course, it's true that in the dark I may mistake a blue for a green ..."

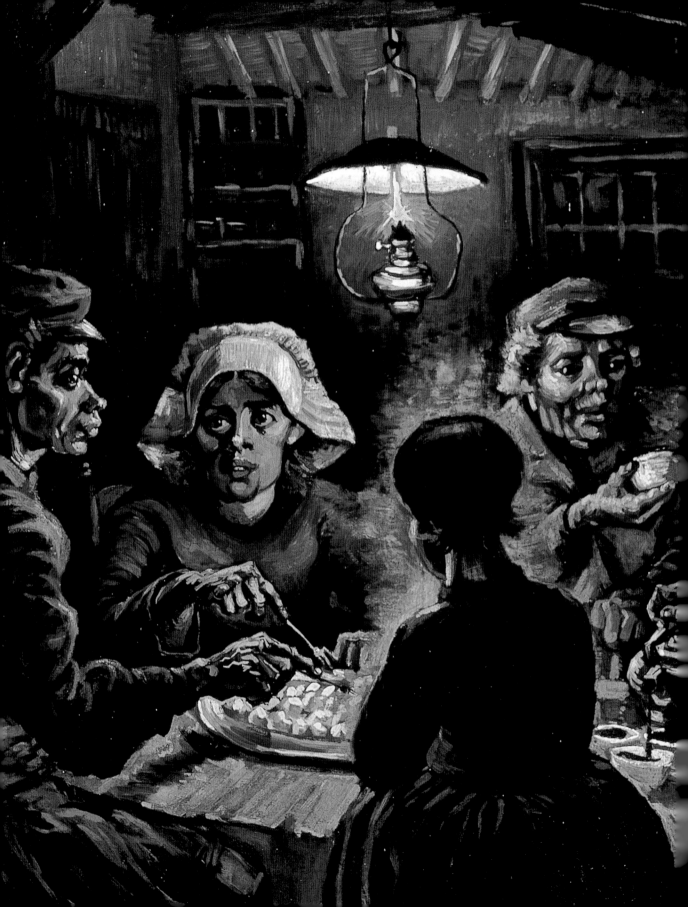

Painting in Black

"On the other hand, you would also be mistaken if you thought that I would do well to follow your advice literally to become an engraver of invoice headings and visiting cards, or a bookkeeper or a carpenter's apprentice – or else to devote myself to being a baker – or many similar things (curiously different and hard to combine) that other people advise me."

Riled by the advice from his family that Theo had relayed to him on a visit to the Borinage region in 1879, van Gogh showed no sign of life from the coalfields for more than two months – and when he did communicate, he was rather spiteful. Even in his deepest despair, van Gogh was continuously insulting to Theo. There had been no reason for their lack of communication. After all, it was "better to be friends than to be dead to each other, the more so because, as long as one is not really dead, it seems a shame, or at least childish, to pretend to be so … The hours we spent together have at least given us the assurance that we are both still in the land of the living."

Van Gogh's wording is certainly dry, yet he is unable to conceal his lasting shock at being misunderstood by his own family or his fear that they thought they could do without him. The prospect of being good-for-nothing or even becoming a burden to others was intolerable for him.

Van Gogh did not try to disguise the depression he experienced in the bleak surroundings of the Borinage, his 'black country', where he was doing missionary work at his own expense. He had lost the confidence of his family, had no credit left and his future looked bleak. Between desperation and self-pity, he found himself going round and round in circles: "How could I in any way be of any use to anybody? How can I be of use in the world? Can't I serve some purpose and be of any good?" He was no 'idle fellow', it was only that he did not yet have a clear vision of his goal, but it would "become more definite, will stand out slowly and surely, as the rough draft becomes a sketch, and the sketch becomes a picture – little by little, by working seriously on it, by pondering over the idea, vague at first, over the thought that was fleeting and passing, till it gets fixed." Until that point, he would just have to cope: "I am a man of passions, capable of and subject to doing more or less foolish things, which I happen to repent, more or less, afterwards." Certain things that issue from his pen 'somewhat at random' strike the reader as guardedly sentimental, from talk of a 'caged bird' to 'inner fire'. But even the pathos cannot hide the nub of the issue: his need to justify his existence. His years of loneliness and his never-ending poverty only added to his fears. After almost

The Potato Eaters, April/May 1885

After producing many preparatory studies of it, van Gogh completed his first large oil painting in May 1885. It combines all the tones of his palette during his first creative phase: "… and the colour they are painted in now is like the colour of a very dusty potato, unpeeled of course."

Old Woman with Dark Bonnet, Winter 1885

Following pages
Harbour Workers in Arles, August 1888

Van Gogh thought the workers on the coal barges a 'very fine subject'. In August 1888, despite stressful work on his series of sunflowers, he was swamped with new ideas for paintings and was completely taken with the thought of creating a new, non-Impressionistic style of painting.

two years of infrequent and superficial correspondence, van Gogh poured his heart out to Theo: even he could not live without companionship, he was "not made of stone or iron, like a hydrant or a lamppost."

What had happened? What had caused the minister's son to veer off the straight and narrow? In the art trade in The Hague and later in London, van Gogh had initially cut a good figure. His unrequited love for the daughter of his landlady in London so deadened his enthusiasm, however, that he was transferred to Goupil & Co. in Paris where he lost his job soon after. Even years later, his time at the company still preyed on his mind; a full six years proved to be indigestible. At least they kindled his enthusiasm for art and collecting that saw him through the dark days of his life. Even when still an apprentice in The Hague, van Gogh laid the foundation for a remarkable collection of woodcuts that grew over the years with purchases – and exchanges – from Theo and friends. After the fiasco of the art trade, however, he tried to choose a career unrelated to the fine arts. Back in England, he worked as a teacher, lay preacher and school fee collector but found the pay 'pretty depressing' – just like the tabacco. By Christmas 1876, the dejected twenty-four-year-old found himself back at home in Holland.

Neither as a bookseller nor as a prospective student of divinity who bowed out before sitting his entrance exams was he able to impress anyone. His next goal was pursued with all the more fervour: he would become a 'sower of God's word', a preacher, a reformed minister like his father. When this attempt failed – he was said to lack the necessary preaching skills – here ended the chapter of van Gogh as missionary – and indeed a whole book. The Church as an institution was finished for him: "For me, that God of the clergymen is as dead as a doornail."

When the institutions of the Church lost their significance for van Gogh, literature acquired a new meaning for him. However, in August 1880, when nothing was going right for him, the most important straw he clutched at was not the novels of his revered Zola, but woodcuts. "Send me what you can, and do not fear for me. If I can only continue to work, somehow or other it will set me right again." Still in the Borinage, long not having earned a thing and with no missionary work, van Gogh, now aged twenty-seven, took up drawing – or rather painting, because to him prints and oil paintings appeared to be intimately connected. The shading of a drawing was equivalent to 'painting in black'. In his present bleak surroundings, attractive motifs were limited, but he made do with chimneys and mountains of coal, miners working underground and "scurrying little black figures, like ants in a nest": "… sowing seed, digging potatoes, washing turnips; everything is picturesque, even gathering wood, and it looks much like Montmartre."

From his collection, Theo sent his brother prints to copy or pages full of detailed descriptions of the works that he handled as a young art dealer in Paris. Things took a turn for the better, van Gogh was drawing and "from that moment everything changed

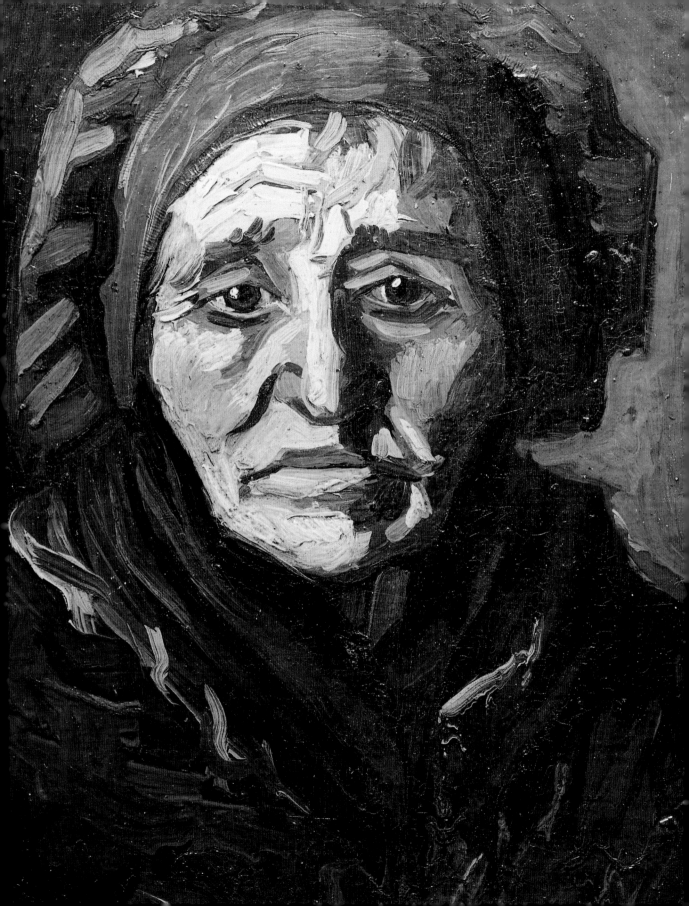

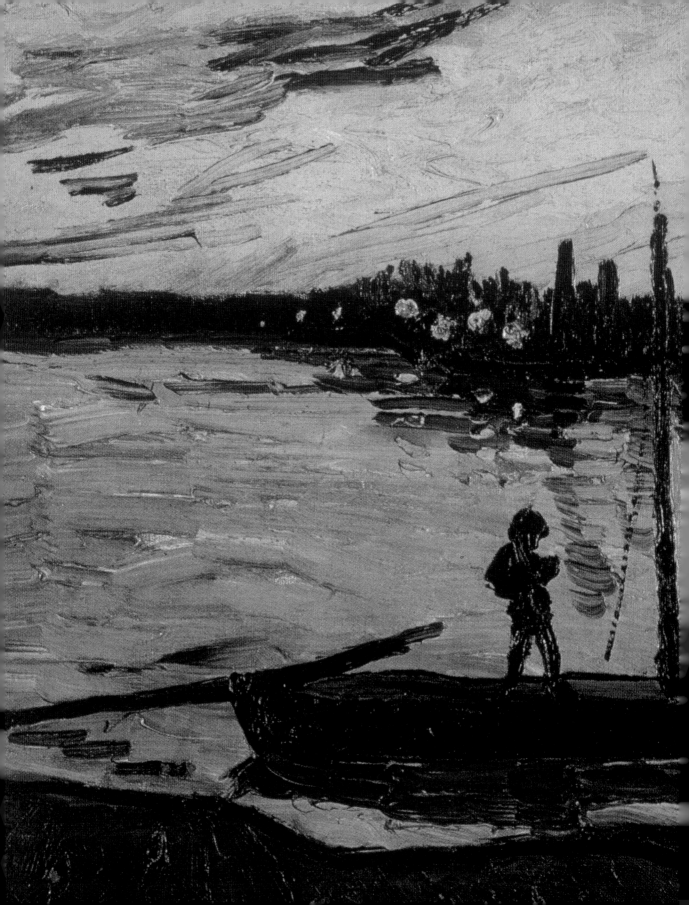

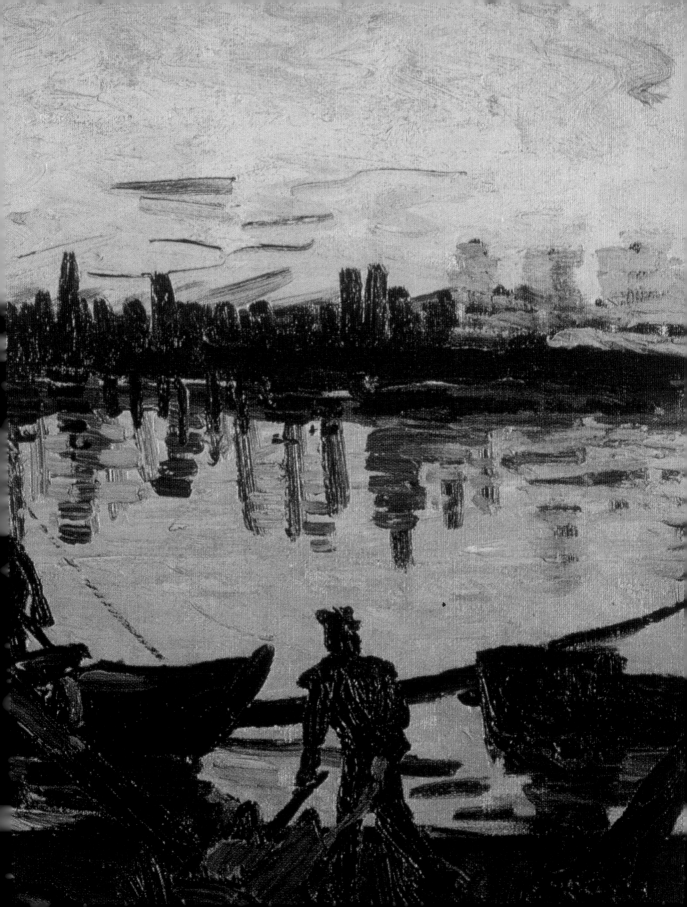

for me, and now I am on my way again, my pencil yielding to me a little more, seemingly more so by the day."

Van Gogh and his vocation were drawing closer, but it troubled him that it was so late in the day: his youth had already passed, he said. Time and again, he had to assure Theo – and himself – that he was on the right road. "Not being suited to business or academic study does not prove at all that I am not fit to be a painter. On the contrary, if I had been able to be a clergyman or an art dealer, then perhaps I should not have been suited to drawing and painting, and should neither have resigned nor accepted my dismissal as such."

It was September 1881 when van Gogh first included sketches of his figure drawings in his letters to Theo, and commented enthusiastically about his progress in drawing. Twelve sketches showed Theo how his brother was working from models, men and women digging, sowing and ploughing. They were, he quickly added, "scribbled in no time", but what counted was the step forward that van Gogh made with them: "… my drawing has changed, the technique as well as the results."

Now regarding himself as a figure artist, van Gogh saw figures everywhere over the following months. In winter 1881, he was making plans for the spring when he would be able to draw trees outdoors "just as if they were figures. I mean, you have to consider them mainly in terms of outline, proportion and their relation to each another." No matter how modest the location, in nature he saw "expression and soul, so to speak … A row of pollard willows sometimes resembles a procession of almshouse men. A few days ago I saw a group of Savoy cabbages standing frozen and benumbed, and it reminded me of a group of women in their thin petticoats and old shawls."

When Theo gave Vincent a paintbox and some other equipment in the summer of 1882, there was no stopping him: "You must not take it amiss if I write to you again – it is only to tell you that painting is such a joy to me." Van Gogh stocked up on watercolours and brushes as well as large tubes of paint – they were cheaper, after all. So now he had it, his "practical palette with healthy colours." He also had a perspective frame made that allowed him to "make a solid drawing and indicate the main lines and proportions" whatever the lie of the land.

Van Gogh was convinced that the peasants of Brabant should be his main motif. A 'peasant painter among peasants', he saw himself as one of their own, regardless of his own bourgeois background that occasionally made him feel superior to his models. "Painting peasant life is a serious thing … one must paint the peasants as if one were one, feeling, thinking as they do," a conviction that van Gogh adopted from his great model, Jean-François Millet. Millet's name occurs around 200 times in van Gogh's letters, throughout eighteen years of correspondence. In fact, he adopted a motto of Millet's that he himself probably never expected to take literally: 'dans l'art il faut y mettre sa peau' (for art, you have to give your body and soul). Sacrifice everything for a life of

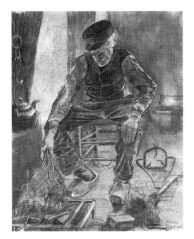

Farmer Sitting at the Fireside, November 1881

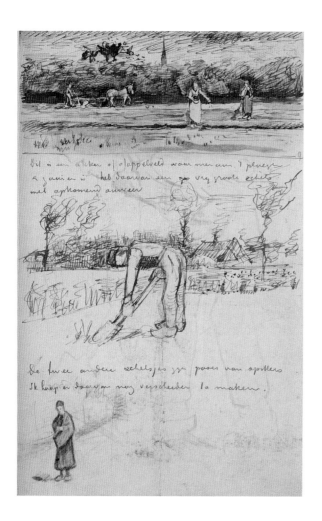

left
Letter to Theo, September 1881

below
Letter to Theo, September 1881

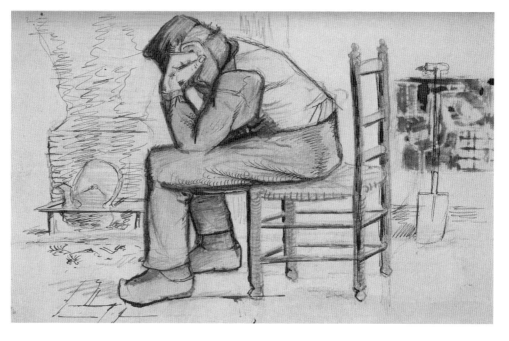

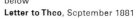

Sower with Setting Sun, June 1888

art without sparing himself was van Gogh's belief from the beginning as a working man among working men. When, aged thirty-two, he consulted a doctor in Amsterdam because he was suffering from bouts of coughing, stomach cramps and was losing his teeth, he felt some pride when the doctor commented: "I suppose you are an ironworker." The callused skin on van Gogh's hands was more than just a by-product of his own line of work. And the clothes that covered his tough hide were often a source of offence – and not just to his own family: he liked to walk around in one of the old coats his father wore as a minister. Van Gogh's unkempt appearance was frequently the subject of conversation, in fact. Once, having bought a suit, he even felt obliged to send samples of it home with the assurance that there was nothing loud or unusual about it! Even in this respect, Millet may also have acted as his role model: as an itinerant landscape painter, he was more concerned with things other than a smart outfit. Besides, for van Gogh it was almost a matter of honour not to be distinguishable from his subjects, whether travellers in the third-class waiting rooms or the ragmen in the streets: "Then my ugly face and shabby coat harmonize perfectly with the surroundings and I am myself and work with pleasure." Not only his clothes suffered from the way he worked; his painting equipment also took a few knocks. "I had some extra expense because my paintbox broke when I was forced to jump down from a height to collect my things in a hurry. Where the coal is loaded on the railway, I had to get out the way of a startled horse."

In his habits but above all in his choice of motifs, the Dutchman frequently took Millet as his model. Van Gogh's interest in the motif of the sower, to which he turned repeatedly throughout his decade as a creative artist, can be traced back to the Frenchman's influence. Van Gogh's earliest attempt at it, a copy after Millet, dates from 1881; even a matter of months before his death, he was still haunted by the great master's subject. In Arles, too, the motif was of immense significance: "I have been longing to do a sower for such a long time, but the things I've wanted for a long time never come off." Besides being an actual motif in his work, metaphorically, too, sowing and reaping is a central theme throughout his career as a painter. In 1882, van Gogh felt confident that "… one harvests one's studies just the way a farmer harvests his crops." By sowing studies, he reaped paintings. In this context, he regarded the lithographic reproduction of drawings as almost 'miraculous' because it was so fruitful. In the light of his poor selling prospects, however, a pessimistic mood or rather a sense of disillusion set in: "one begins to see more and more clearly that life is only a kind of sowing time, and the harvest is not here."

At the outset of his career as an artist, van Gogh focussed on the peasants and weavers of Brabant, whose livelihoods he felt were akin to his own. As a trained art dealer able to move in very different social circles, did he perhaps delight in being slightly provocative? Was he trying to spoil his chances of being asked back into people's 'beautiful homes'. Did he never again want to mix in the circle that made him so insecure?

Letter to Theo, September 1881

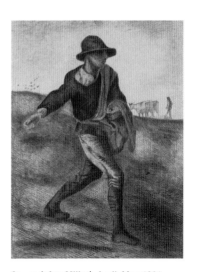

Sower (after Millet), April–May 1881

Following pages
Wheat Field with Farmer and Sun, June/September 1889

Like his great model Millet, van Gogh also used the motif of the Sower over and over again in the ten years of his life as a creative artist. In his late paintings, the Reaper took the place of the Sower.

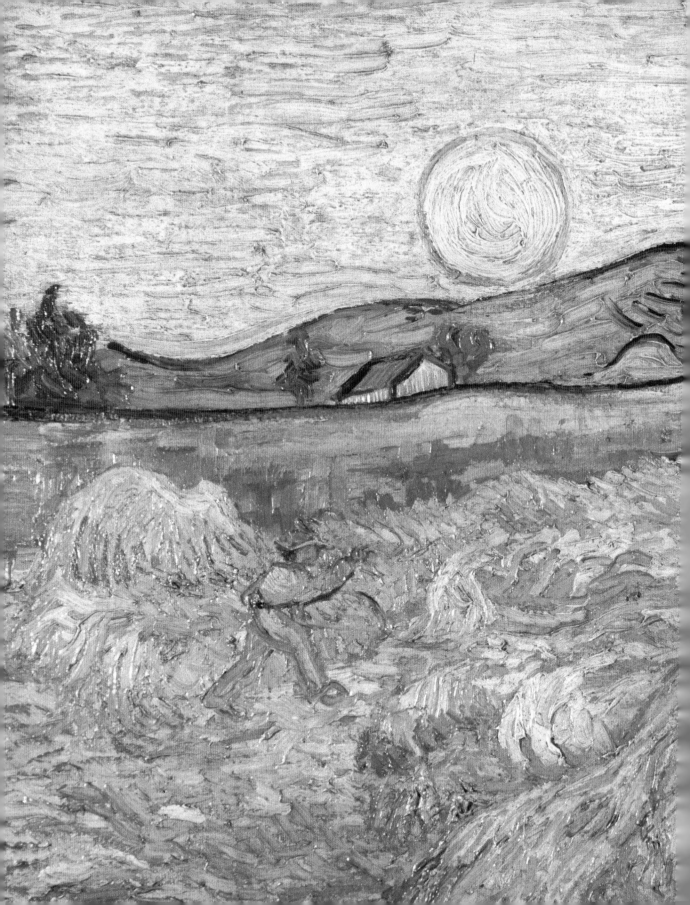

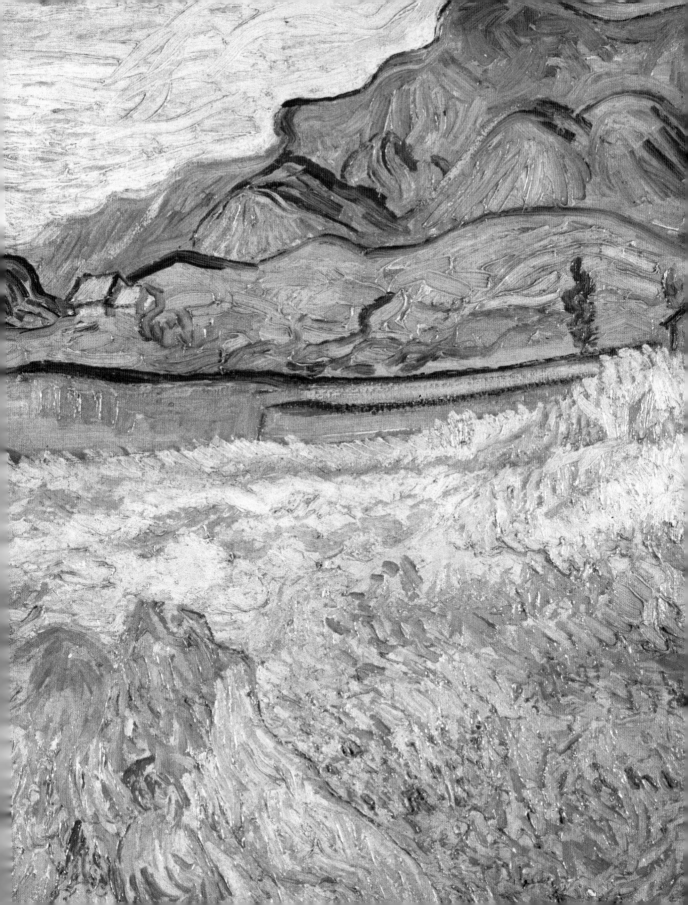

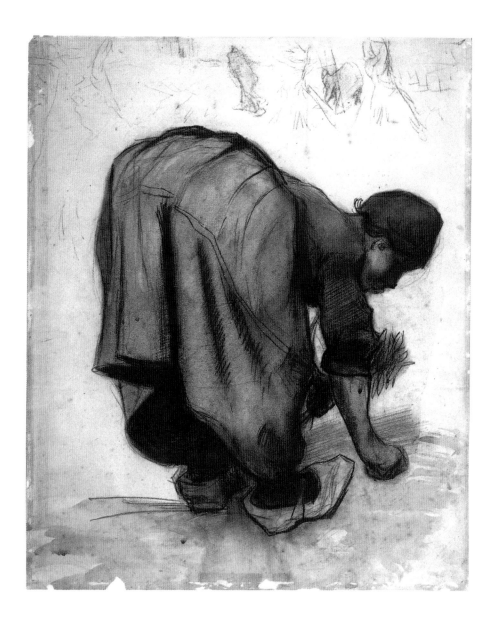

Stooped Woman Binding Sheaves,
August 1885

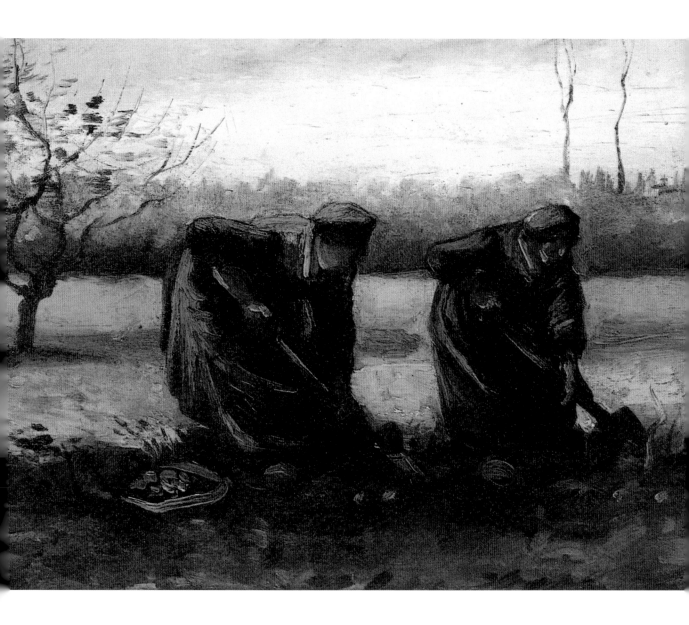

Two Women Digging Potatoes,
August 1885

A man for whom 'painting was in the very marrow of my bones' and who had a passion for drawing out of doors, van Gogh viewed his coarse appearance mainly as a result of his style of working. When, aged thirty, he described lying down in the sand in front of the old root of a tree to draw it, his choice of a plain linen smock is understandable. He thought nothing of mere external beauty: "because I do not want the beauty to come from the material, but from within myself. When I am a little more advanced I shall occasionally dress up nicely – that means I shall work with a more effective drawing material. And then if only I have some power within me, things will go doubly smoothly and the result will be better than I expected."

Even a peasant painter needs the odd bit of metropolitan excitement, however. In two decades of working life, from being an apprentice in the art trade to becoming a painter, van Gogh crossed half of Europe, moving from the country to the city and back again. Having barely concluded that the empty spaces of Drenthe were the right place for him to be, he ended his self-imposed isolation. Just after arriving in Antwerp, his thoughts again turned to country life, despite the fact that he desperately needed to see pictures and people again. The isolation of the Borinage coalfields was followed by a spell in Brussels; after rural Etten came the buzz of The Hague; from Paris, the centre of art, he moved to the tranquillity of Arles. After a year of severe attacks and weeks of melancholy, before being admitted to the psychiatric hospital at Saint-Paul-de-Mausole, van Gogh declared that his venture south had failed. Northern France would, it was hoped, take the pressure off him.

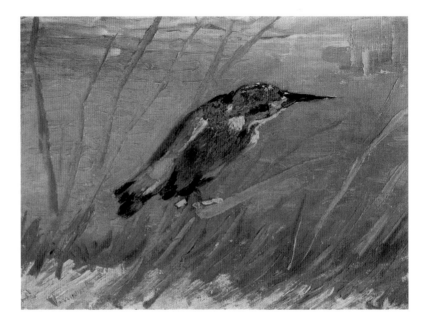

Kingfisher, October/December 1886

Roots, April 1882

Following pages
Autumn Landscape, October 1885

In autumn 1885, when van Gogh was 'completely absorbed in the laws of colour', he produced countless autumn studies. This autumn landscape was one of the few early paintings that pleased him; he described its contrasting colours to Theo in detail.

Old Man from the Sanatorium,
September 1882

Van Gogh drew farmers and weavers
when he worked in the countryside.
When living in a town, his preferred
motifs were the goings-on at the edge
of town – and society.

Van Gogh certainly cannot be accused of being unwilling to move, even as a schoolboy. On arriving in Antwerp in 1885, he commented laconically that the city "will probably prove to be like everything everywhere, namely disillusioning but with its own atmosphere." As was always the case when he arrived somewhere, things at first looked rosy (as they would in an icily-cold and snow-covered Arles almost two years later). He soon felt at ease in Antwerp where there was lots to see and he was "already full of ideas, also for the time when I shall be in the country again." Time and again, he moved back "at least for a short while" to the "land of pictures and painters" until he was seized by loneliness there too: "… *where* I am matters not in the least."

What did matter to him during his lifetime was figure painting, which – again surprisingly in line with academic tradition – he regarded as his artistic destiny. The trouble with figure painting is not the work itself, but finding models. Van Gogh just had no success in finding any. In Nuenen, the Catholic priests even forbade the peasants from sitting for him, and offered them money not to! If van Gogh found that unnerving, the smear campaign that was set in motion when the maid from *The Potato Eaters* fell pregnant, was decidedly less amusing. That particular episode resulted in his shifting the focus of his work to landscapes and still lifes. When he did finally find models to sit for him, his pictures filled his "portfolios in proportion to [their] emptying my purse."

There are obvious reasons for van Gogh's interest in the peasants of the countryside, but even on his visits to Brussels or The Hague, he turned to the impoverished souls living on the edge of town. He wanted to earn his crust in no different a manner to them, through honest, hard work. Like many of the residents of Brabant, still untouched by industrialisation, he sometimes 'wove', but in earthy hues of brown – and lots of it! In Nuenen between December 1883 and November 1885, he produced around 500 paintings, watercolours, drawings and studies, including almost 100 heads. When it was not snowing or bitterly cold, van Gogh worked outside – although sometimes he worked outside even in bad weather because "nature appears to me to be an indescribably beautiful exhibition of the Black-and-White Society."

An almost monochrome palette allowed him to concentrate on the effects of light and shade, while the peasant genre satisfied his demand that art serve the people. For *The Potato Eaters*, his first large oil painting on which he made a start in late spring 1885, the meticulous worker made stacks of drawings, wholly in line with the academic practice that he barely knew. He produced series not only of heads and hands, but also of the potato fork and the kettle that changed its position several times over the course of the composition's development. A belief he had formulated years earlier still seemed to hold true for him there: "Drawing is the backbone of painting, the skeleton that supports all the rest." Yet despite all his preparatory studies, he even declared that the result would not satisfy him: "But I think I shall get it finished, always in a comparative sense, for in reality I shall never think my own work ready or finished." That said, he asked

Opposite page
The Potato Eaters, April/May 1885

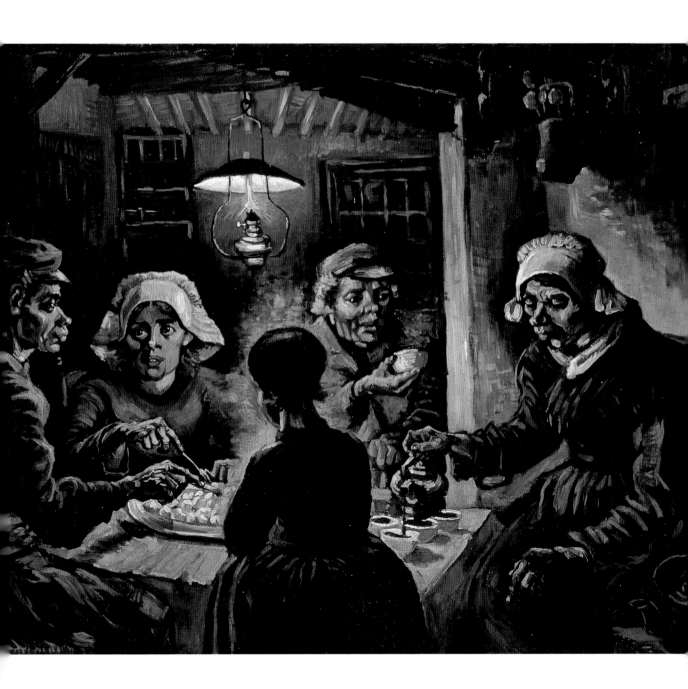

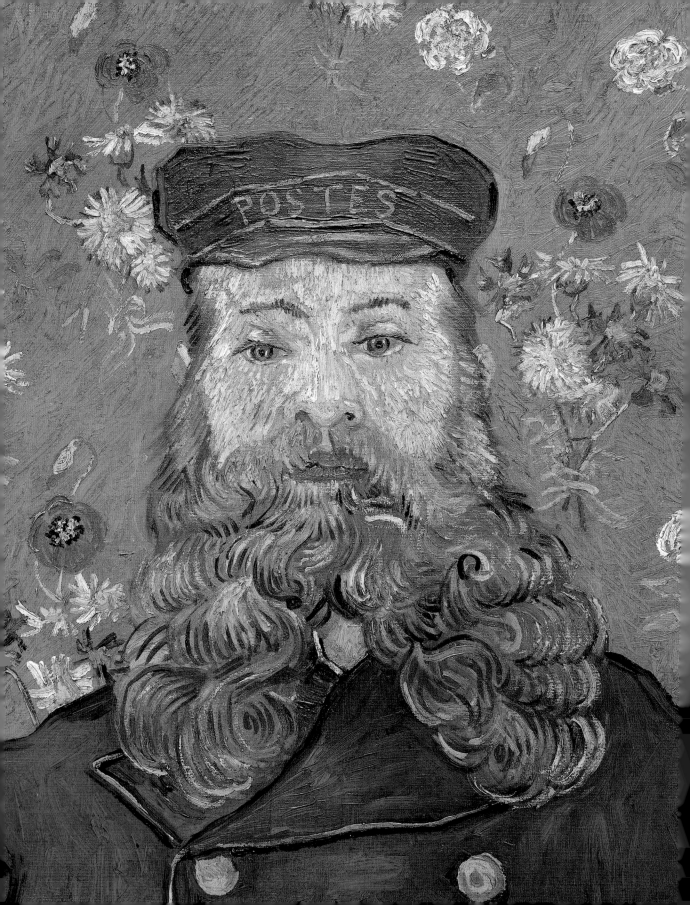

Theo to sell the studies of the picture that he had sent to him little by little. Even before he began painting, van Gogh had a lithograph of the picture made and sent it to Paris – not only to Theo, but also to art dealers and to his friend Anthon van Rappard. On one occasion van Gogh took van Rappard's negative reaction to heart and replied by return of post, telling him that their friendship was over. A month passed before he felt able to reply to his friend's criticism. He even felt that Theo was owed an explanation: "All winter long I have had the threads of this tissue in my hands, and have searched for the ultimate pattern; and though it has become a tissue of rough, coarse aspect, nevertheless the threads have been chosen carefully and according to certain rules. And it might prove to be a real *peasant picture. I know it is.*" The problem was not that this was a peasant picture; its critics took issue with the unconvincing proportions of the figures, their brutality and the colour of the painting. They were presented to van Gogh as reasons why his work would not sell.

While putting his art on paper and canvas required "a rather great exertion of strength, and this day after day," van Gogh was unable to earn a living from it and this hurt him increasingly. Going for interviews was not really his thing. His fear of rejection as well as his defiance and seeming indifference grew over the years. Nonetheless, with prints of his works – even in the form of visiting cards, such as the one of the *Loom and Weaver* – he hoped to begin exchanging works with dealers and buyers. During van Gogh's phase of drawing weavers and peasants, even Theo often had to be won over and van Gogh made a sincere effort to make his choice of motif palatable to his brother. From his very first efforts at drawing at the Academy in Brussels, it was van Gogh's wish to be able to sell his own work and to keep his head above water without relying on his brother: "I have had no 'guidance' or 'teaching' from others to speak of, but have taught myself; no wonder my technique, considered superficially, differs from that of others. But that's no reason for my work to remain unsaleable."

Although he had a love-hate relationship with the art trade following his time at Goupil, the type of recognition it offered became more important to him the more progress he made as a painter. He tried his luck as an illustrator for English magazines, but in this, too, his shyness made him his own worst enemy. The issue of selling his work is a constant in Vincent's letters – just as much as the issue of giving it away. Theo was not wrong in his belief that his brother's interest in his own self was lacking. The thought occasionally occurred to van Gogh to start something new and unrelated to painting, but in his eyes things hadn't quite got that bad yet. He did not want to accept the necessity of starting anew until he succeeded in 'being seen.' Every time he moved, he trusted to luck, put his health further at risk and confessed to another failure.

In Antwerp, he considered two possibilities: he could hire himself out to businesses as a sign-writer or paint views of the city for visitors. Portrait photography was now widely practiced and also gave him something to think about; another way to earn

The Postman Roulin, February/March 1889

The postman in Arles, Joseph Roulin, would often have taken receipt of van Gogh's paintings for delivery to Theo. Vincent became friendly with him and his family and was pleased that they willingly sat for him. Vincent informed his sister in summer 1888 that Roulin had 'a head somewhat like Socrates.'

Opposite page
Pink Peach Tree in Blossom (in Memory of Mauve), March 1888

Shortly after arriving in Arles, van Gogh learned about the death of his former teacher Anton Mauve. He sent this painting of a pink peach tree to his widow: "I purposely chose the best study I've painted here."

money would surely be to portray the illustrious ladies of Antwerp. So out he went in search of those who could afford to have their portrait painted. Just to be on the safe side, he let Theo know that going out with no money was no pleasure, should he have to resort to paying women to sit for him. But no models meant no portraits, and no money meant no models. Disappointment duly set in again: would his days of 'muddling through' by the skin of his teeth never end? For his lack of success in the art market, he blamed himself less than he did the corrupt art trade. Van Gogh likened it "in many respects to the bulb trade" in the Netherlands which was not only risky but also on the brink of ruin.

La Mousmé (Mousme), 1888

Blue for orange, green for red. Van Gogh sets the young Frenchwoman amid the complementary contrasts of his imagined Japan, which he found in Arles. He called his sitter 'Mousme' after Pierre Lotis' book *Madame Chrysanthème* that was infused with Japonism: "A Mousme is a small Japanese woman, in this case one from Provence ..." he explained to Theo.

Souvenir de Mauve

Greyish Pink and Bright Yellow: The Art of Colour

"Just dash something down when you see a blank canvas staring you in the face with a certain imbecility. You do not know how paralyzing that staring of a blank canvas is; it says to the painter You can't do anything. The canvas stares at you like an idiot, and it hypnotizes some painters, so that they themselves become idiots. Many painters are afraid of the blank canvas, but the blank canvas is afraid of the really passionate painter who is daring – and who has once and for all broken that spell of 'you cannot'."

Vincent to Theo in the autumn of 1884

When he did finally get started, van Gogh showed his canvases just how passionate and daring a painter he was. His rate of work was breathtaking. Even when still in Nuenen, he told Theo that he was capturing his impressions on his canvases rapidly. It was not least the speed at which the Old Masters had worked that fascinated van Gogh, prompting him to study the work of Rembrandt and Frans Hals for hours on end in amazement. "The thing is to do the whole in one rush" became his motto after a visit with Theo to an Amsterdam museum that he described at great length.

The two years that van Gogh spent in Paris were every bit as productive. According to Bernard, van Gogh sometimes produced three pictures a day there, while at the same developing a taste for drink. Cheap wine and lots of absinth became his faithful companions as much as his canvases and tubes of paint. Both habits – painting quickly and drinking no less slowly – he took with him to Arles in the spring of 1888 where he "went on painting like a steam engine." In Auvers, in the north of France, where van Gogh spent the last two months of his life, his rate of work not only continued unabated, it intensified still more. Having already inspired Daubigny, Corot, Cézanne and Gauguin, the small town offered enough subjects to keep van Gogh constantly on the go, and he left behind a picture for every day he spent there. Van Gogh realised that such a rate of work would also attract criticism, but that was not enough to hold him back. He had a convincing argument for Theo who, after all, was meant to sell his brother's work: "I must warn you that everyone will think that I work too fast. Don't you believe a word of it … I know beforehand that people will criticise them as *hasty*. You can say they looked at them too quickly themselves."

Willows at Sunset, March 1888

91

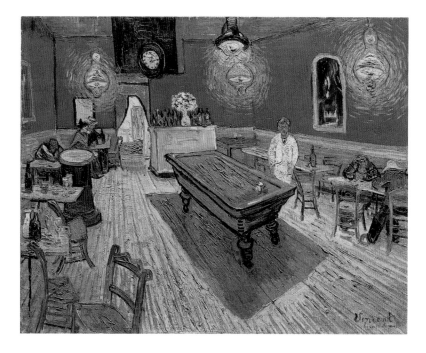

The Night Café, September 1888

Van Gogh also frequented this café. As he wrote to Bernard, it was "a café where night prowlers cease to be night prowlers, because they flop down at a table and spend the whole night thus without prowling at all." To paint this scene of the night café in Arles, van Gogh stayed awake for three nights ... and then felt this blood-red and bright yellow painting was one of his least attractive.

Even at times that, in retrospect, appear to be characterised by an obsessive, uncontrolled and set-to-it kind of painting, van Gogh put every one of his pictures in the context of his work, he included some 'brain work', and worked on the harmony of the pictures that he produced according to 'complex calculations': "The whole thing should become a record of both your and my work."

No less quickly than he filled his canvases, van Gogh sometimes put his decisions into effect. Quite suddenly, he arrived in Paris in spring 1886 – much to Theo's surprise. "I feel that you do not approve of my coming straight to Paris, otherwise you would already have answered me."

Van Gogh was right to assume so. Theo supported the idea in principle as he saw that there was interest in Vincent's work in Paris, but he wanted his brother's move there to be rather more organised. Not a bit of it. Scribbled hastily in pencil on the back of a laundry ticket only a few days later, Vincent's next 'letter' showed that he had already arrived in the city. Would Theo like to meet him in the Louvre? As van Gogh wrote to Theo when he was still living in Holland: "As you are in Paris, I think Paris good, and if it meant that I felt less alone, I would make better progress."

A great champion of "much drawing and little colour," van Gogh felt his palette was 'thawing' at the end of 1885. He now wanted to get away from his pictures of peasants. Having been no more than a necessary mistake, his close study of nature and reality lessened in importance thanks to the power of colour that he now discovered: "One

Opposite page
A Plate with Lemons and a Carafe, Spring 1887

During his early days in Paris, in addition to self-portraits van Gogh also produced still-lifes in which he gradually moved away from a dark palette. His increasingly bright colours reveal his examination of the work of the Impressionists.

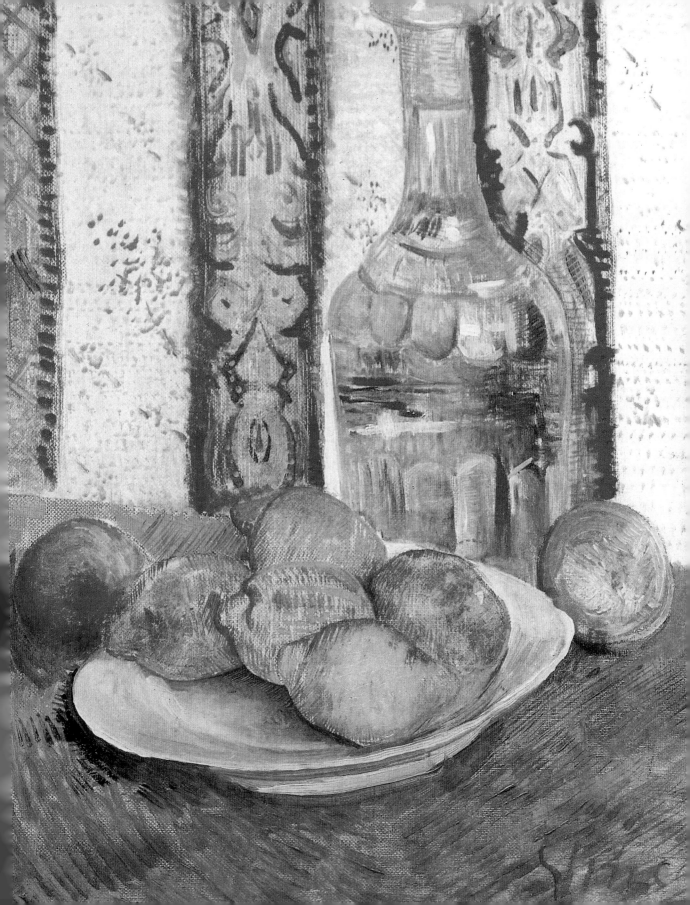

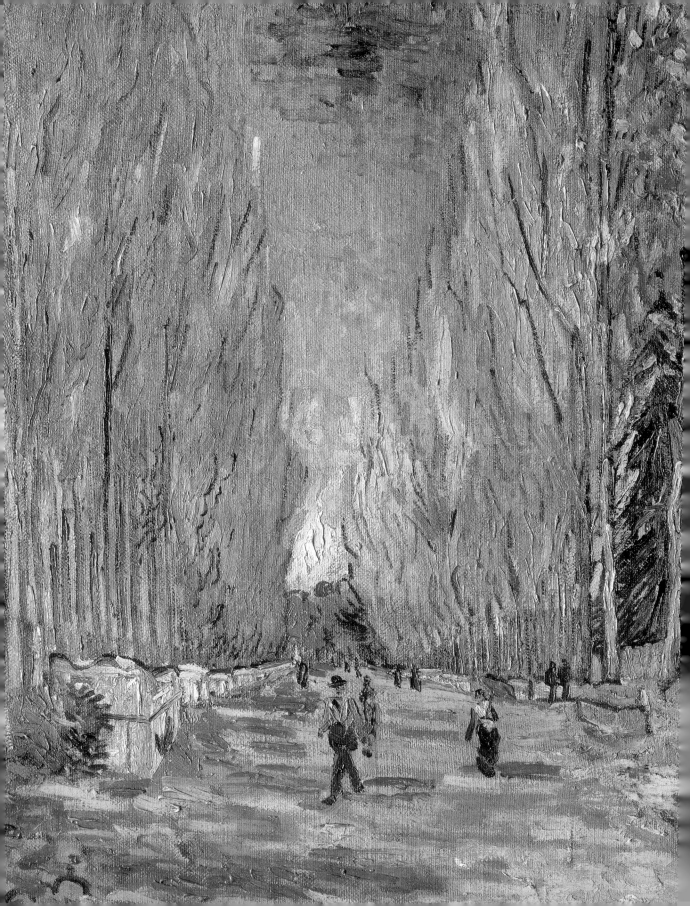

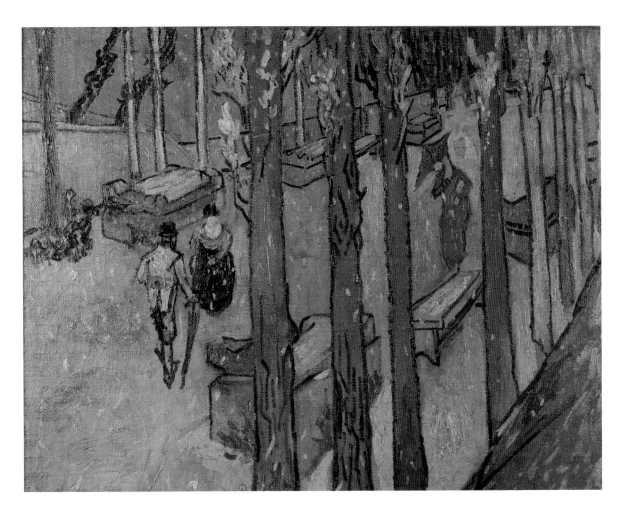

starts by fruitlessly wearing oneself out following nature, and everything goes against the grain; one ends by drawing gently on one's palette and nature finally agrees with it. But these contradictions cannot exist one without the other. For all that it seems to be in vain, it makes one familiar with nature, makes one thoroughly aware of things."

Van Gogh's departure for Paris was prompted not only by the fact that his brother had found his feet in the teeming city, but also because of his own need for new stimuli and the prospect of meeting other artists. He was often torn between his professed status as a self-taught artist and the support he received from other painters, and his frequent changes of residence should also be viewed in this light. Even when he first took art lessons, he realised that it would be necessary to see real art now and then, and that merely copying from printed reproductions would be insufficient. One of his declared aims was to meet other painters. His repeated attempts to gain a foothold in recognised

Les Alyscamps, Falling Autumn Leaves, *c.* 1 November 1888

The Alyscamps had been the main road into Arles since Roman times. Van Gogh paints it flanked by stone tombs. Within the space of a week in autumn 1888, he painted four views of the road from different viewpoints. Gauguin was enthusiastic about these paintings; two of them hung in his room in the Yellow House.

Previous page
Les Alyscamps, Avenue at Arles, *c.* 6 November 1888

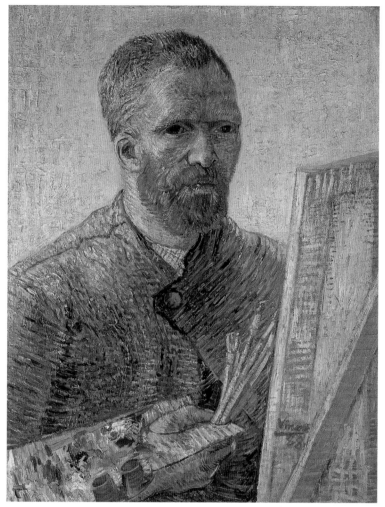

Self-Portrait as an Artist, February 1888

Opposite page
The Painter on the Road to Tarascon, July 1888

Revealing his familiarity with Pointillism, this brightly coloured self-portrait was pro-
duced shortly before van Gogh left for Arles. Six months later, he had moved from
the grey winter of Paris to sun-baked Provence where he set to work "always very
dusty, always more bristlingly loaded, like a porcupine, with brushes, painter's easel,
canvases and other materials."

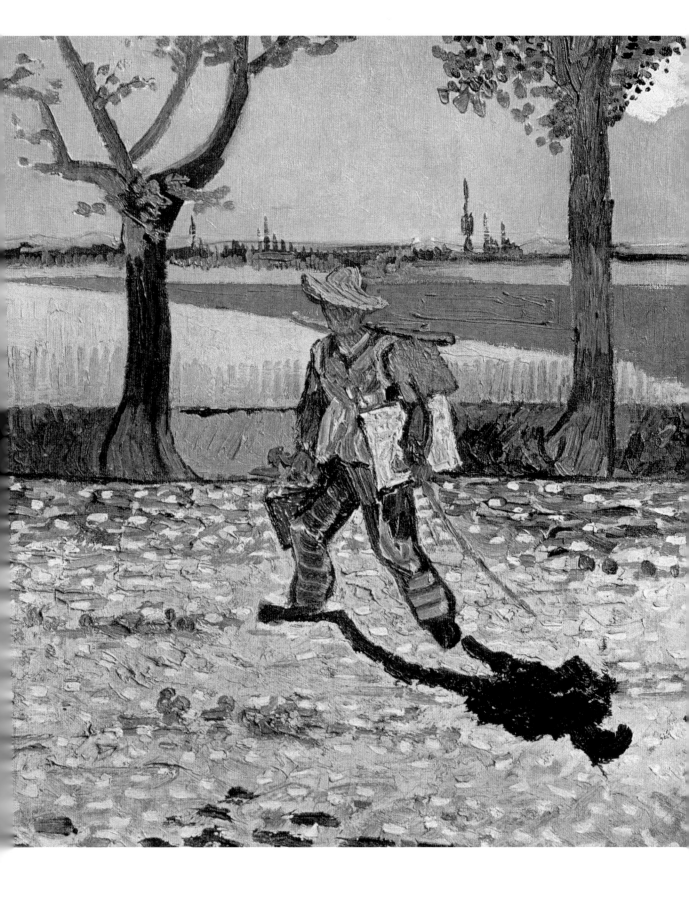

The Crau, Seen from Montmajour,
July 1888

In summer 1888, atop Montmajour, van Gogh made a large-scale pen drawing of the extensive Crau plain in the Rhône delta. He was fascinated by the endlessness of the plain; to him, it seemed as lovely as the sea.

academies stem from his rather conventional understanding of art: "There are laws of proportion, light and shadow and perspective that one must know in order to draw something."

In Paris, van Gogh at first painted everything he saw around him: flowers, the view from Theo's windows and even himself, about thirty times. And just as Impressionism had left him cold on his first visit to the city ten years earlier, now it cast its spell on him. When he arrived in Paris in March 1886, he was still able to wander around the eighth and final Impressionist exhibition and to absorb the paintings of Monet and Renoir at Georges Petit's gallery. Later in the year, van Gogh took advantage of the opportunity to exchange views with fellow painters in the open studio of the history painter Fernand Cormon. Émile Bernard, Toulouse-Lautrec, Louis Anquetin and Charles Laval worked there or still kept in touch. Through these artists, van Gogh met the art dealer Julien Tanguy. By way of payment for paint and canvas, van Gogh let him have quite a few of

Opposite page
Irises, 1889

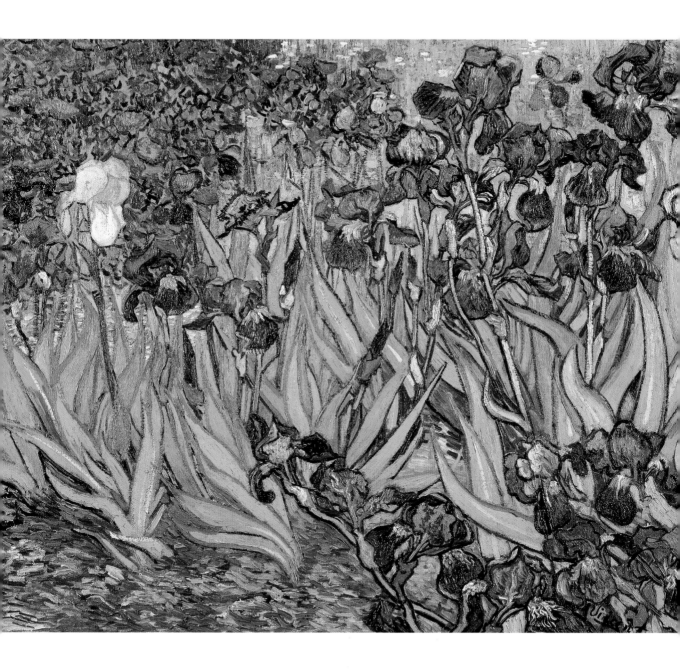

his paintings. On the countless visits he made to Tanguy's small shop, he became familiar with the Pointillists and their work. Van Gogh made friends with Paul Signac, likewise a great fan of Zola, and the two of them often set off together to paint in the city's northern suburbs. Van Gogh also socialized with Pissarro and Guillaumin. In fact, he was finally able to get his own back on Theo by introducing him to his artist friends – quite something for someone who was now a rising dealer in Impressionism.

Just as he had done before when he had no one to model for him, van Gogh produced still lifes that summer, but now mainly of flowers that allowed him to practice using the brighter Impressionist palette, "in order to get accustomed to using a scale of colours other than grey – namely pink, soft and vivid green, light blue, violet, yellow, orange and rich red," as he wrote to Wil. Vincent turned out to be a good organizer: he exhibited his studies in a number of galleries, exchanged work with other artists and arranged exhibitions for 'The Painters of the Petit Boulevard'. This was the name he gave to the artists who showed their work in Montmartre's Boulevard de Clichy to distinguish them from 'The Painters of the Grand Boulevard' who exhibited in the galleries of Durand-Ruel and Petit in the city centre. Yet Paris – "this strange city where one is wretched when one lives there and where it is possible to get somewhere only when one is half dead" – did not do his health any good. Half-dead, he left it; it was time to retreat to the country again.

Van Gogh turned his back on the bleak Paris winter and fled to Provence, the Japan of his imagination. His idealised view of the South had such a hold on van Gogh that even the thick snow he found on arriving there did not put him off. He had found his Japan and thought his landscape drawings were "essentially more Japanese than all the others … Perhaps they ought to be framed in thin bamboo."

When he had recovered somewhat from his Parisian excesses, he revised his view of the South. Taking less of a cue from Zola, he saw himself in the Provence of Daudet and his quixotic protagonist, the would-be adventurer Tartarin. He now saw "things more objectively than in his wishful thinking" and his memories of Holland were quickly transfigured. It was the countryside that so reminded him of home: "The difference lies in the colour. Here everything is sulphur yellow in colour and the sun strikes one's eyes."

Given that van Gogh did not speak Provençal, Arles took his mind off things – not least his feeling of homesickness – only to a limited extent, and he would go for days on end without speaking to a soul. He had no choice but to devote himself to painting and felt so inspired that he immediately took some 'preventive measures' for the good of his health, eating more regularly and drinking less, getting enough sleep and buying sensible clothes – and even imposing on himself a short break from painting, all done "to stick it out in the long run and to be able to work regularly." One drop of bitterness was his paint bill, forever the 'drawback of painting'. Van Gogh's style of painting was now

The Church in Auvers, June 1890

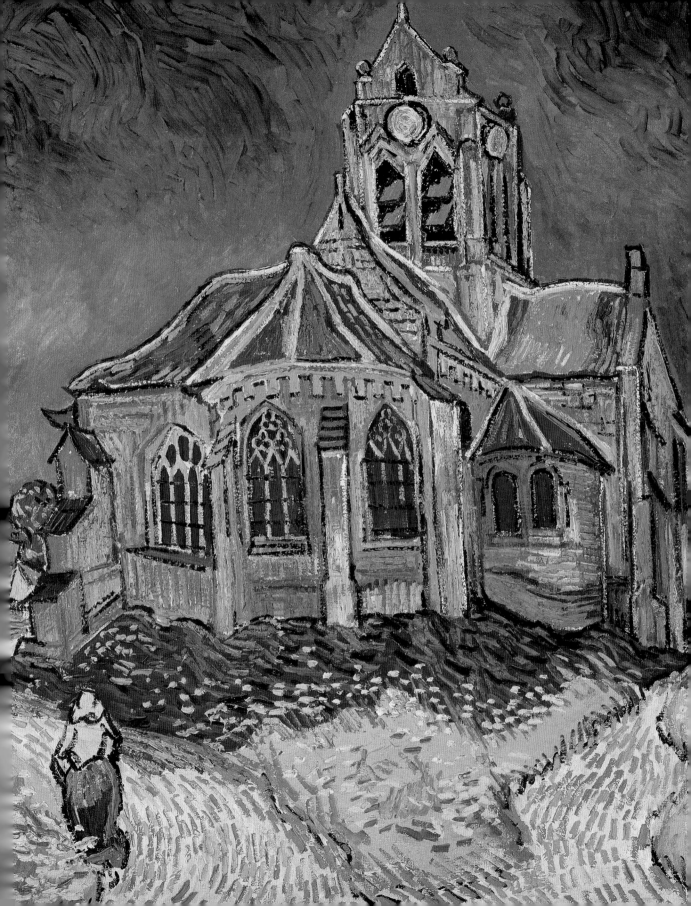

Opposite page
Blossoming Almond Twig in a Glass,
March 1888

Letter to Theo, April 1888

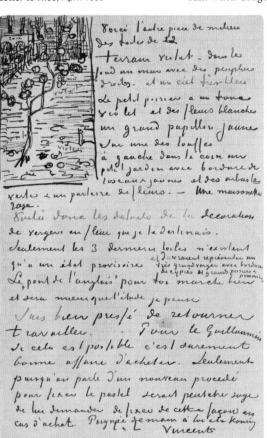

very expensive. Even when he produced his first oil paintings in The Hague, he painted less with his brushes than he did with his tubes of paint straight onto his canvas.

Requests to Theo for paint and brushes multiplied in Arles where in fifteen months van Gogh produced around 200 pictures, besides 100 drawings and water-colours as well as over 200 letters. Whenever his conscience about the vast amount of material he was ordering from his brother began to trouble him, van Gogh suggested switching to drawing, which would cost less. He tried to convince Theo that his palette would calm down again at the onset of winter. Until then, he would have to hurry if he wanted to follow the rhythm of nature: not only sunflowers faded quickly, the blossom on the fruit trees did so, too, not to mention the grape harvest – and the weather, including the mistral, was always a factor. And if that wasn't enough, van Gogh was pursuing another, and no less demanding, project: a complete decorative scheme, 'a symphony in blue and yellow', that he had devised for his new home in Arles. It made his heart beat faster; everything was just rosy in his yellow house 'on a square, right in the sun'. When Gauguin, a man revered by van Gogh, suggested he would join him in Arles, van Gogh set about with a passion making a home for them by getting in beds, a stove, drawing tables – all the while trying to convince himself that he did not want to make a big fuss over his artist friend. He just happened to turn the nicest room in the house into the guest bedroom. Large flower paintings, a dozen of them, were to decorate Gauguin's room. Full of joy, van Gogh wrote to Bernard: "I am thinking of decorating my studio with half a dozen pictures of 'Sunflowers', a decoration in which the raw or broken chrome yellows will blaze forth on various backgrounds – blue, from the palest malachite green to *royal blue*, framed in thin strips of wood painted with orange lead. Effects like those of stained-glass windows in a Gothic church."

Having for years nurtured his dream of an artists' colony like that at Pont-Aven, van Gogh now saw himself in the fortunate position of being able to prepare a home for his weary Parisian colleagues and above all their master, Gauguin: "I want to make it *an artists' house* – not *precious*, on the contrary nothing precious, but everything from the chairs to the pictures having character." His dream of a harmonious association of artists was not restricted to Arles; even in Drenthe, van Gogh had dreamt of one, and in Antwerp, too, he was convinced "that a major cause of the widespread poverty among artists lies in the divisions between them, in their lack of cooperation and in the fact that they are not good to each other, but false."

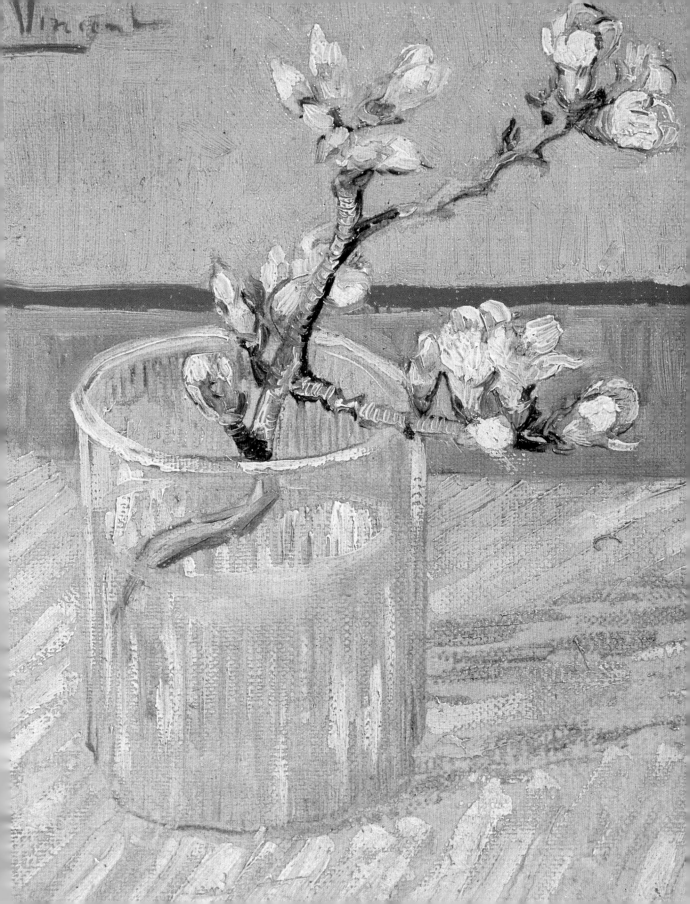

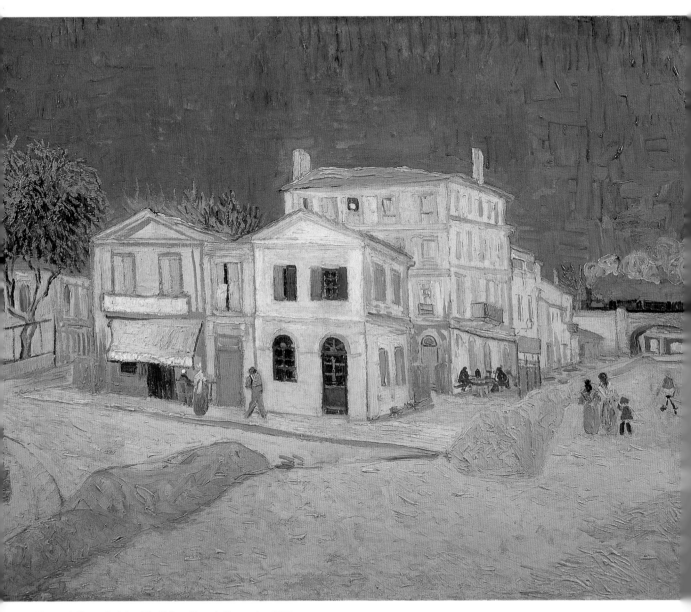

Vincent's House in Arles (The Yellow House), September 1888

To realise his dream of an artists' colony, van Gogh rented a
yellow house on Place Lamartine in Arles. He made a sketch of
the street and described the scene to Theo: "… It's terrific, these
houses, yellow in the sun, and the incomparable freshness of
the blue. And everywhere the ground is yellow too." He furnished
his bedroom simply – and hung up some of his own works.

He was totally absorbed in his plans for a decorative scheme. In his letters to Theo, he described his excessive and utterly exhausting workload that he felt was not doing his health any good at all; it was even making him "quite absent-minded and incapable of doing many ordinary things." "I have less need of company than of furiously working hard, and that is why I am boldly ordering canvas and paints. It's the only time I feel I am alive, when I am drudging away at my work." This he did day in, day out, and then through the night, too, when he discovered a new passion, that of painting the night sky. Vincent told his little sister about it in a letter: "At present I absolutely want to paint a starry sky. It often seems to me that the night is still more richly coloured than the day, having hues of the most intense violets, blues and greens. If only you pay attention to it you will see that certain stars are citron-yellow, others have a pink glow, or a green, blue and forget-me-not brilliance … It amuses me enormously to paint the night right on the spot … Of course, it's true that in the dark I may mistake a blue for a green, a blue-lilac for a pink-lilac …"

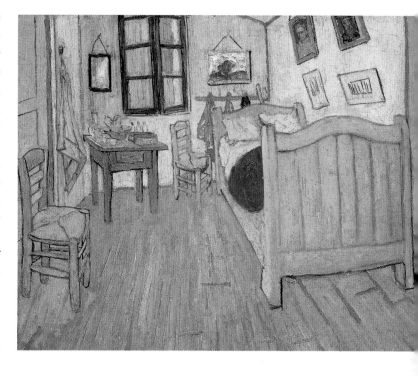

Vincent's Bedroom in Arles, October 1888

Van Gogh's star was burning brightly around this time – albeit far away at Pont-Aven in Brittany. Long hoped for by van Gogh, Gauguin's arrival in Arles in October 1888, after months of indecision over whether to refuse or accept the invitation, was the first and last time that a dream of van Gogh's was realised. His 'Atelier du Midi' could now count on a new addition; ardent as ever, van Gogh saw 'a new era' on the horizon. Nevertheless, his 'Impressionist Society' stood on shaky ground. The two artists were like fire and water – or as van Gogh himself put it, like day and night. Their two empty chairs, Gauguin's armchair in the candlelight and van Gogh's chair in the sunshine, speak volumes about this short-lived artists' commune.

The nine weeks that both artists spent together were nevertheless extremely productive. Van Gogh experimented with Gauguin's use of flat areas of colour and admired his ability to work from pure imagination. Every now and then, the Frenchman joined the Dutchman on his excursions into the countryside. Heated debates about art alternated with visits to the brothel and drinking sessions, but above all, both men worked hard. Come December, however, the situation had changed dramatically.

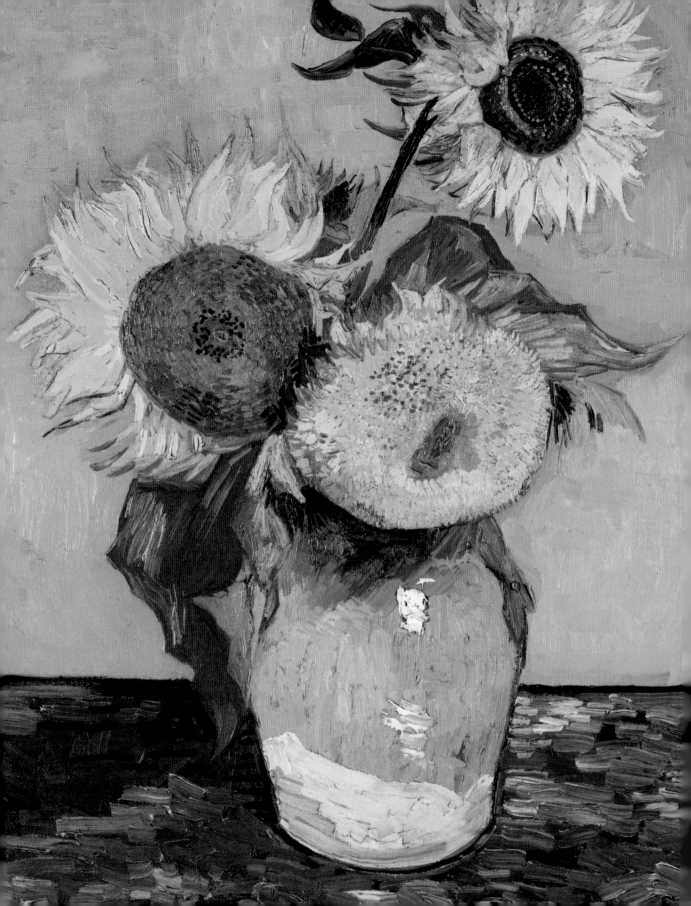

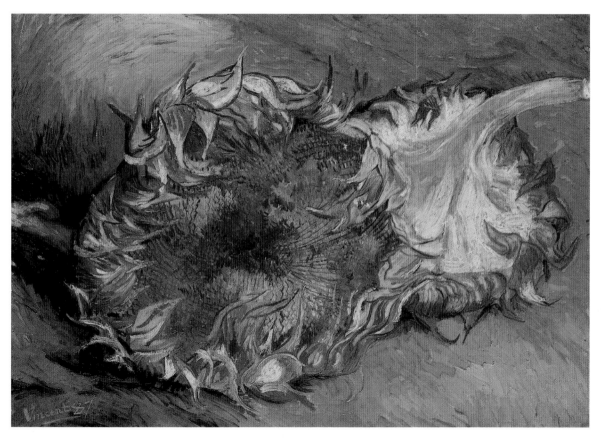

Two Cut Sunflowers, 1887

Following pages
Van Gogh's Chair, December 1888

Gauguin's Chair, December 1888

Van Gogh found these two paintings 'odd enough'. At first sight, their subject is amusing. Why does an artist focus so much attention – and use so much paint – on two chairs? Van Gogh described both paintings as counterparts. He painted them in December 1888 when Gauguin had been sharing the studio with him for a number of weeks and their contradictory natures were clearly leading to tension between them.

Opposite page
Sunflowers, 1888

107

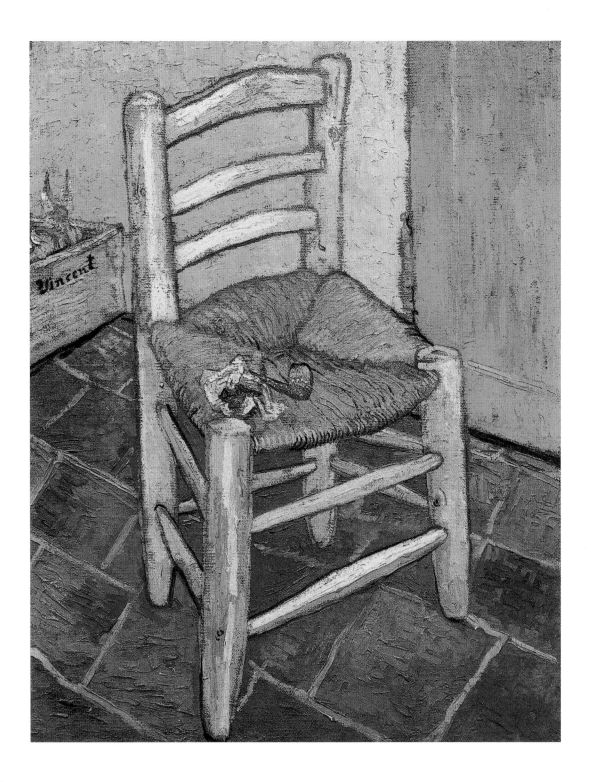

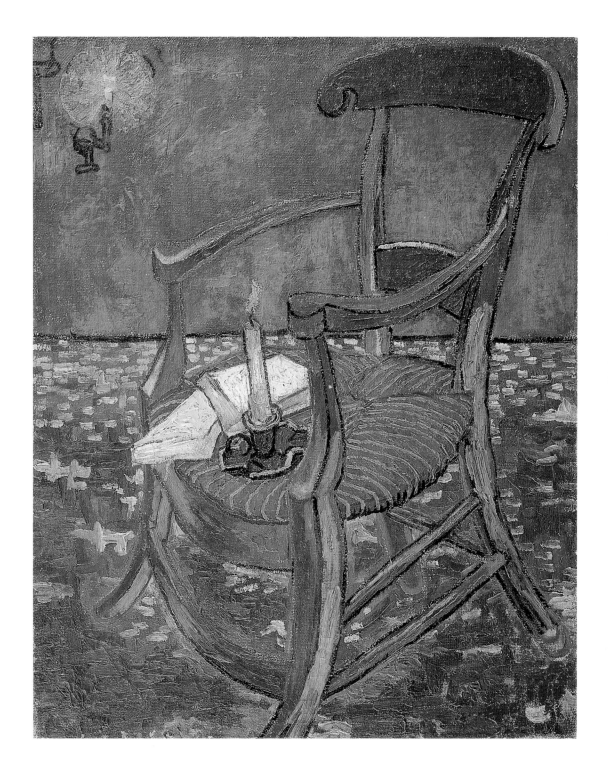

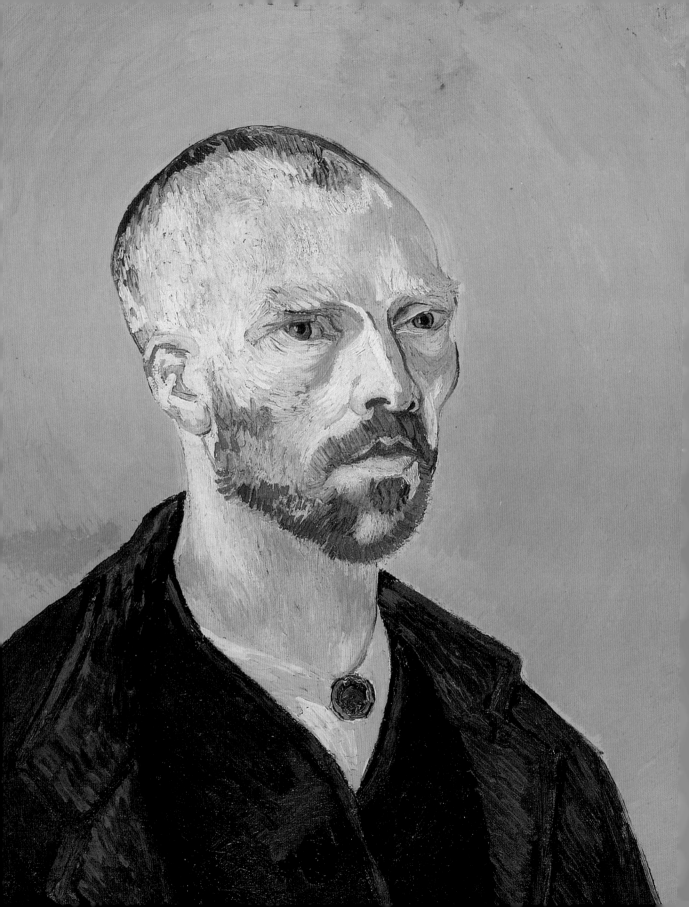

Van Gogh was certain that Gauguin would either "definitely go, or else definitely stay" in Arles. Some days later, things came to a head with a 'trivial matter' when, following an argument, Gauguin left their shared studio and van Gogh cut off part of his left earlobe with his razor. Gauguin summoned Theo in a telegraph, to van Gogh's great displeasure, and van Gogh tried to brush aside all their concerns about him. He hoped he had "just had simply an artist's fit" that brought him down to earth from his artistic flights of fancy. He readily admitted to abandoning himself to them: "… but all the same it is true that to attain the high yellow note that I attained last summer, I really had to be pretty well keyed up." It was already clear to van Gogh during the summer just what he was doing to himself with his art: "As it is, I am going to pieces and killing myself," but he was used to trouble. However he landed back in hospital the following February because sleeplessness and delusions were causing him grief, and he was gripped by fear of further attacks. He tried to work and, as he had often done, read books to stop himself going under. Among others, *Uncle Tom's Cabin* would provide 'a few sound ideas in my head'. A book of health tips took the place of Zola's novel *La Joie*

Paul Gauguin, **Self-Portrait with Bernard's Portrait 'Les misérables'**, 1888

In autumn 1888, van Gogh exchanged some paintings, including self-portraits, with Gauguin, Bernard and other artists in Paris. He took the opportunity to compare his work with that of his friends and wrote confidently: "My portrait, which I am sending to Gauguin in exchange, holds its own, I am sure of that." His self-portrait as a Buddhist monk reveals how he viewed himself around this time: a man with a dual nature, that of a monk and an artist.

Opposite page
Self-Portrait, September 1888

Opposite page
The Red Vineyard, November 1888

Van Gogh enthusiastically described to Theo the autumnal vineyard that he painted several times when sharing the Arles studio with Gauguin: "But on Sunday if you had been with us, you would have seen a red vineyard, all red like red wine."

Still-Life with Onions and a Plate, January 1889

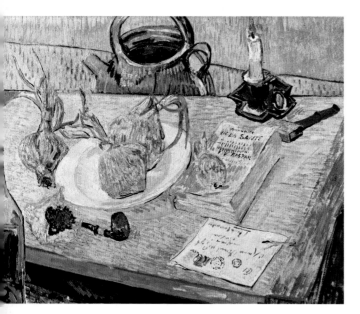

de vivre, once prominently positioned in an early still life with books. The title, *Annuaire de la Santé*, is clearly seen in the picture that van Gogh produced after returning home from hospital for the first time.

In April, van Gogh decided that therapy on its own was not enough. An idea he had long had must have been a real shock to Theo: van Gogh wanted to enter an asylum. "It will be enough, I hope, if I tell you that I feel unable to take a new studio and to stay there alone – here in Arles or elsewhere, for the moment it is all the same; I have tried to make up my mind to begin again, but at the moment it's not possible. I should be afraid of losing the power to work, which is coming back to me now, by forcing myself and by having all the other responsibilities of a studio on my shoulders besides. Temporarily I wish to remain shut up as much for my own peace of mind as for other people's." Theo tried to make the situation better than it seemed and fulsomely praised the pictures that van Gogh sent him. When he and his wife Johanna were furnishing their new home with van Gogh's landscapes, he consoled himself with the thought that "they make the rooms so gay, and there is such an intensity of truth, of the true countryside in them, in each of them." By now they not only decorated the walls of his brother's home or Père Tanguy's shop: during his time in Arles, interest in van Gogh's work had been growing and he had come to the attention of the critics. His *Red Vineyard* was sold in February 1890 and he received invitations to show his work, although each time he thought long and hard about the pros and cons of doing so. Theo agreed with him: "… do not despair, for assuredly better days will come to you." Van Gogh's plan to overcome his illness by working was in fact no more than what he had already been doing all his life, Theo wrote.

Van Gogh, too, tried his best to project confidence. When still in the asylum at Saint-Rémy, he timidly began to dream about his 'association of artists' again. The more the company of other inmates frightened him, the more important painting became to him, at first through the barred windows of his room and then in the grounds of the asylum. Eventually, when he was able once more to paint rolling fields of corn, he applied his oils to the canvas in thick impasto. The Sower is no longer to be found, instead the Reaper steps onto the stage: "For I see in this reaper – a vague figure fighting like a devil in the midst of the heat to get to the end of his task – I see in him the image of death … so it is – if you like – the opposite to that sower I tried to do before. But there's nothing sad in this death, it goes its way in broad daylight with a sun flooding everything with a light of pure gold."

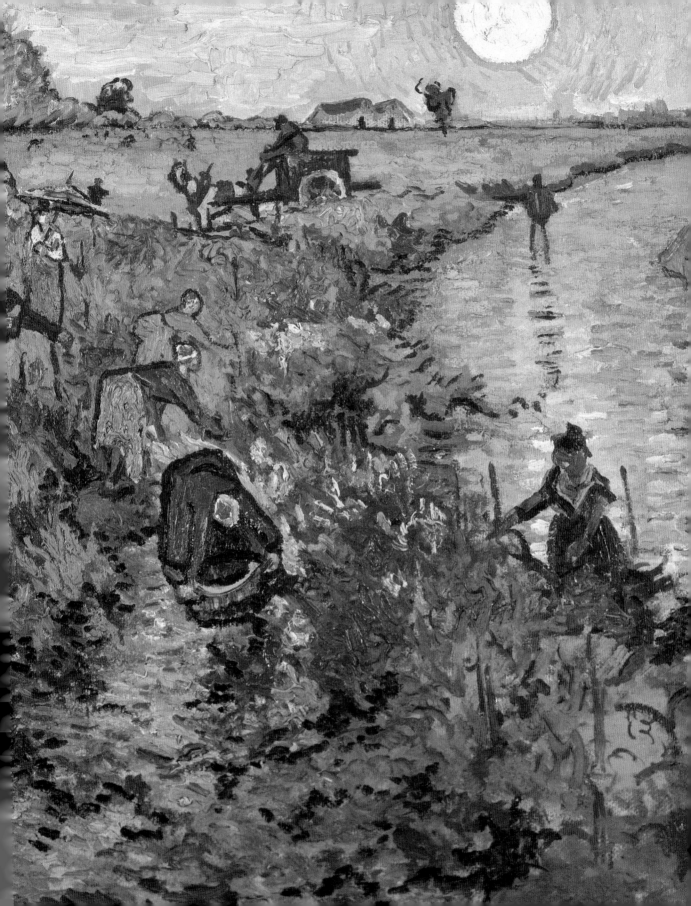

Despite his vulnerable health, van Gogh continued to make plans for a studio with Gauguin and the painter de Haan. Their lack of interest and his own flagging strength, however, caused him to abandon any hope. Finally, he let go of his dream. Like everything else, he wrote, it was doomed to failure anyway.

With his eyes open, he then pressed ahead staring Fate in the eye: "All the same, I know well that healing comes – if one is brave – from within through profound resignation to suffering and death, through the surrender of your own will and of your self-love. But that is no use to me, I love to paint …"

Sower with Setting Sun, 1888

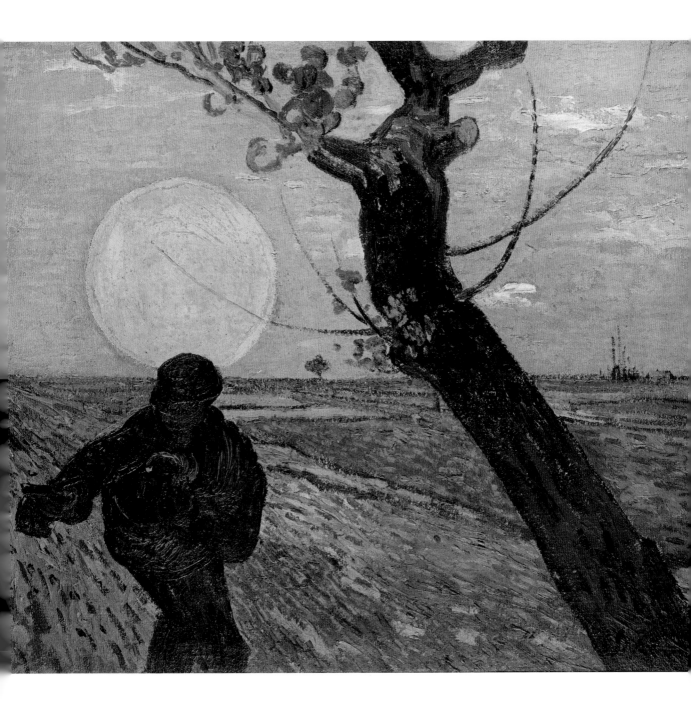

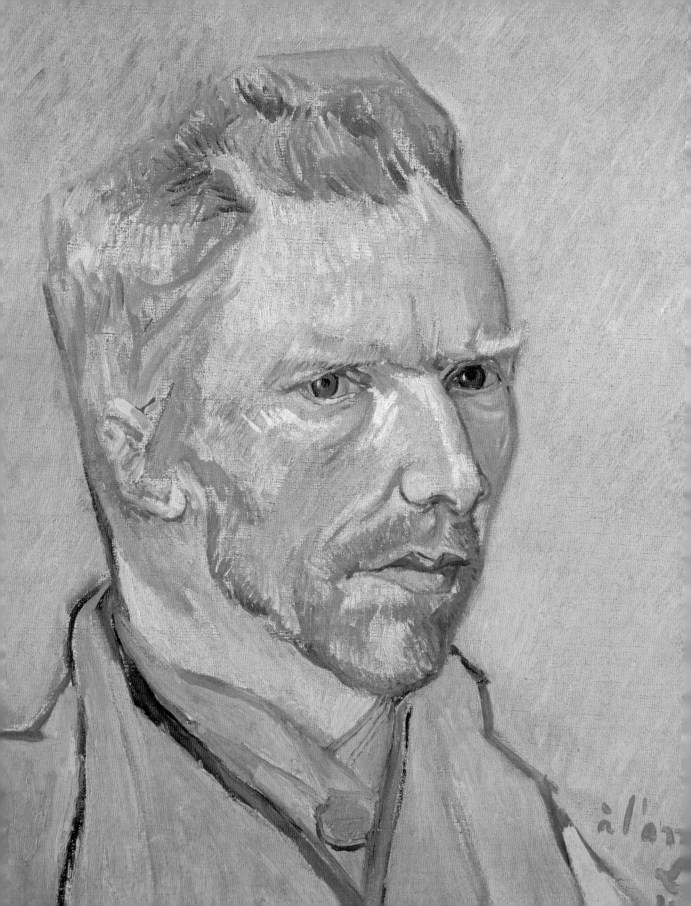

Biography and Works

Born on 30 March **1853** in the Dutch village of Zundert (near Breda) in the province of North Brabant and christened Vincent Willem van Gogh. His father, Theodorus, was minister to the parish.

On 1 May **1857**, four years after Vincent was born, his mother, Anna Cornelia Carbentus, gave birth to his brother Theo (Theodorus). He would become the most important, and sometimes only, figure to whom Vincent could turn in his life.

From **1861** to **1864** Vincent attended the village school; from **1864**, he was sent to boarding school in nearby Zevenbergen.

Two years later, Vincent became a pupil at the secondary school at Tilburg. His art teacher was Constantin Huysmans who had a particular interest in painting landscapes and the interiors of peasants' homes. In March **1868**, Vincent returned home for a short time to discuss his future career.

Aged sixteen, he started an apprenticeship at Goupil & Co., art dealers with an office in The Hague that was run by his uncle Vincent (Cent). Vincent jnr. began collecting prints and occasionally produced small drawings himself.

In **1872**, from The Hague, Vincent wrote his first letters to his brother; their correspondence continued uninterrupted until his death.

In June **1873**, Vincent was moved to the company's London branch. On route there, he visited Paris for the first time. Just as Vincent departed for London, Theo began his apprenticeship in the company's Brussels branch and was soon sent to The Hague.

1853 The US Navy reaches Japan, ending two centuries of Japanese isolation; the country resumes trading with the West.

1854 Trade agreement between Japan and the USA. Charles Dickens publishes his novel *Hard Times*.

1855 Ingres and Delacroix are among the artists showing their work at the World Fair in Paris.

1856 Félix Bracquemond discovers prints by Hokusai in a shop in Paris and becomes one of the first proponents of japonaiserie. First major economic depression in the United States. Publication of Charles Baudelaire's *Les Fleurs du mal*.

1859 Publication of Charles Darwin's *On the Origin of Species by Means of Natural Selection*, his abstract on the theory of evolution; the first edition sells out immediately.

1861 Manet enjoys great success at the Salon, the official art exhibition held annually in Paris.

1862 Japanese art, among other styles, is exhibited at the International Exhibition in London.
Victor Hugo completes his novel *Les Misérables*.

1863 The Salon jury rejects Manet's painting *Déjeuner sur l'herbe*, prompting the establishment of the *Salon des refusés* by Napoleon III.

Death of Eugène Delacroix. Completion of Garnier's Paris Opera House.

1864 Publication of Leo Tolstoy's *War and Peace*. Karl Marx co-founds the First International Working Men's Association. The first Geneva Convention is signed.

Aged twenty-two, Vincent was transferred to Paris in May **1875**. In London, his unrequited love for his landlady's daughter had badly affected his willingness to work. He spent almost a year in Paris where he worked for Goupil, but with little interest. Bible study was his main focus of attention. In March **1876**, his career as an art dealer came to an end when he was dismissed.

Vincent returned to England rather than to Holland. From April **1876**, he found work as an assistant teacher, at first in Ramsgate then, moving with the school, in Isleworth in west London where he worked as a teacher and lay preacher until November, returning to his parents' home for the Christmas holidays.

At the wish of his parents, he did not return to London. From January to April **1877**, Vincent worked instead in a bookshop in the town of Dordrecht, the job having been found for him by his father. Vincent decided to study divinity in Amsterdam.

In May, Vincent moved into his uncle's house in the capital and prepared for the university entrance exam by taking tuition in Latin and Greek. In August **1878**, he dropped his plans to go to university so that he could reach his goal sooner: he wanted to become a missionary.

Aged twenty-five, Vincent enrolled in a training course for missionaries in the town of Laeken, near Brussels; he did not finish it, however. In November 1878, he decided to move to the Borinage coal-mining area in the south of Belgium. On behalf of the Church, he worked as a missionary for a few months, but was soon dismissed because he was too inclined to give away all his possessions and did not make a good preacher. Nevertheless, Vincent stayed on in the Borinage until September **1880**, often going for weeks on end without any money. He mainly studied textbooks on art, and time and again made copies of woodcuts from his collection and also drew the miners he saw around him. Despite the infrequent contact with his brother, Theo was the first to learn about Vincent's new choice of profession: he had decided to become an artist. In autumn 1880, he moved to Brussels for six months and attended classes at the city's Academy. Vincent

1865 Abraham Lincoln assassinated. Émile Zola publishes his first novel, *La Confession de Claude*.

1866 Alfred Nobel invents dynamite.

1867 Franz Joseph I crowned king of Austria-Hungary. Japanese art is shown at the World Fair in Paris. Publication of the first volume of *Das Kapital* by Karl Marx. Deaths of Baudelaire and Ingres.

1869 First International Art Exhibition held in Munich. The Suez Canal opens. Publication of Alphonse Daudet's *Lettres de mon Moulin*.

1870 Start of the Franco-Prussian War. Napoleon III deposed. The Third Republic is proclaimed.

1871 Wilhelm I becomes German emperor. Paris surrenders to Prussia; a ceasefire is agreed; the Paris Commune rebels and collapses. Zola publishes *La fortune des Rougon*, the first novel in his twenty-volume series *Les Rougon-Macquart*.

1872 Publication of Friedrich Nietzsche's first work *The Birth of Tragedy*. In Paris Claude Monet exhibits his painting *Impression*, thus giving rise to the name of a new style of art. The Paris art dealer Paul Durand-Ruel organises the first of four Impressionist exhibitions in London.

1873 Worldwide economic depression. The slump in prices in Paris triggers a recession in France lasting six years. Napoleon III dies in England.

1874 The first Impressionist exhibition is held in Paris.

1875 Deaths of Jean François Millet and Jean-Baptiste Camille Corot, two significant representatives of Realism.

1876 The second Impressionist exhibition is held. Auguste Renoir paints *Le Moulin de la Galette*. Gauguin exhibits at the Salon. Alexander Graham Bell presents the first telephone at the World Fair in Philadelphia. 1ˢᵗ Bayreuth Festival opens with Wagner's *Ring des Nibelungen*.

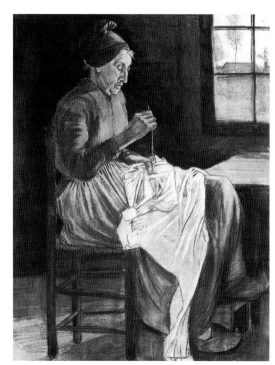

Woman Sewing, late 1881

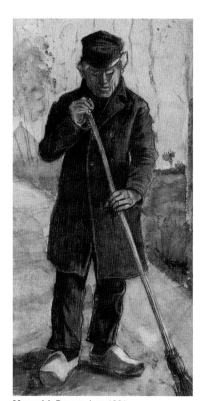

Man with Broom, late 1881

Page 116
Self-Portrait, Arles, November/December 1888

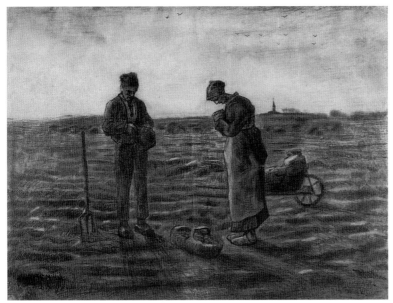

The Angelus (after Millet), early 1881

"I am very happy to get models. I am also trying to get a horse and a donkey."

Etten, August/September 1881

"I spent an afternoon and part of an evening with Mauve, and I saw many beautiful things in his studio. My own drawings seemed to interest Mauve more. He gave me a great many hints which I was glad to get, and I have arranged to come back to see him in a relatively short time when I have some new studies."

Vincent to Theo
Etten, August/September 1881

Windmills near Dordrecht, 1881

Garden with Carpenter's Yard and Laundry, seen from Vincent's Room, May 1882

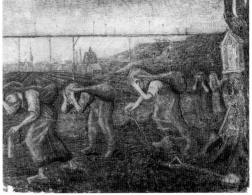

The Bearers of Burden, early 1881

met Anton van Rappard who became a long-standing friend. By this time, Theo had been moved to the Goupil office in Paris. In 1880, he started subsidising his older brother.

In May **1881**, Vincent returned to his parents' home, now in Etten. He fell in love with his cousin, a recently widowed woman by the name of Kee Vos who, however, did not return his affection. No one in the family could understand his insistent courtship of Kee. Vincent's growing alienation from organised religion culminated in a row with his father; Vincent left his parents' home in December.

At the beginning of **1882**, aged twenty-eight, Vincent took lodgings in The Hague, a centre of Dutch artistic life, and moved into his first studio. For a short time, Vincent was tutored in art by Anton Mauve, his uncle by marriage and, besides Jozef Israëls and Hendrik Mesdag, one of the leading members of The Hague School. In addition, Vincent participated in life classes and worked in watercolours.

Another uncle commissioned Vincent to produce twelve views of The Hague; in them, the young artist made working-class life his main theme.

In spring 1882, he met Clasina Maria Hoornik (Sien), a former seamstress turned prostitute, and moved into a studio flat with her and her daughter. His family distanced itself from him. Theo, too, was nonplussed by such a misalliance. Vincent drew and painted a great deal out of doors. He was in poor health and in the summer had to spend a few weeks in the local hospital. Theo informed his parents about Vincent's ill health, and his parents offered support; his father visited him in The Hague. Sien gave birth to a son in July.
In autumn 1882, Vincent started to work in oils. As he wanted to acquire the skills needed to work as an illustrator of journals, he also tried his hand at lithography.

In October **1883**, Vincent left Sien and the children as he felt they were preventing him from making progress as an artist. He also had large debts that were finally settled by Theo. Vincent moved to the rural province of Drenthe although its desolate moors could not hold him for long. After three months, he

1877 The third Impressionist exhibition is held in Paris. Death of Gustave Courbet. Publication of Zola's *L'Assommoir*.

1878 A Japanese pavilion is included in the World Fair in Paris. Besides prints, bronzes, papier-mâché and lacquer work are on show. Death of the landscape painter Charles-François Daubigny.

1879 The fourth Impressionist exhibition opens to the public; there are annual exhibitions until 1882.

1880 Franz Marc and Ernst Ludwig Kirchner born.

1881 Pablo Picasso born in Malaga.

1882 Italy, Germany and Austria-Hungary sign the Triple Alliance.

Edgar Degas' *Women Ironing*.

Compulsory education introduced in France.

1883 Japanese prints are exhibited in Georges Petit's gallery in Paris. Édouard Manet dies.

The group of artists known as *Les Vingt* is established in Brussels.

Publication of Zola's *Ladies' Delight*.

Woman Praying, Spring 1883

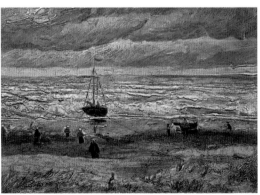

Beach with Figures and Sea with a Ship, August 1882

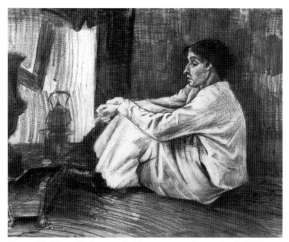

Sien with Cigar Sitting on the Floor near a Stove, April 1882

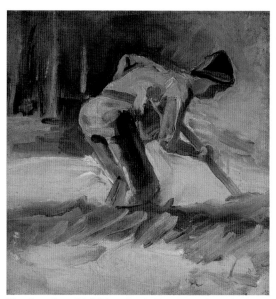

Man Stooping with Stick or Spade, The Hague, August 1882

"Today I promised myself something, that is, to treat my illness, or rather what remains of it as if it didn't exist."

Vincent to Theo
The Hague, 21 July 1882

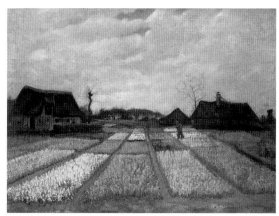

The New Church and Old Houses in The Hague, 1882/83

Bulb Field, The Hague, April 1883

for long. After three months, he moved back to his parents' home, now in Nuenen, where he created a small studio for himself. Vincent gave his first art lessons to pupils in the nearby town of Eindhoven.

In early summer **1884**, the two brothers reached a new agreement: Vincent was to regard his monthly allowance from Theo as payment for his work. Vincent now started to send his studies, paintings and drawings to his brother who supported him not only financially, but also kept him informed about the latest artistic trends and techniques.

Vincent painted and drew the weavers of Brabant in endless variations. While he was greatly interested in studying colour, especially complementary contrasts, his palette nonetheless remained one of earthy hues.

Vincent turned to portraiture because he thought it lucrative. When he had no money to pay models, he produced numerous still-lifes.

A family neighbour fell in love with Vincent who did not return her affection, however. The young woman attempted suicide, precipitating the artist into another crisis.

Worldwide economic depression.

Opening of the Metropolitan Opera House in New York.

The world's first skyscraper in Chicago is ready for occupation.

1884 The first *Salon des Indépendants* is held in Paris.

Les Vingt exhibit work for the first time.

A major exhibition to commemorate Manet is held in Paris.

The *Société des Artistes Indépendantes* is founded, again in Paris; Signac and Seurat are among the participants.

Publication of Zola's *La Joie de vivre*.

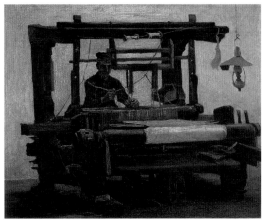

Weaver, April/May 1884

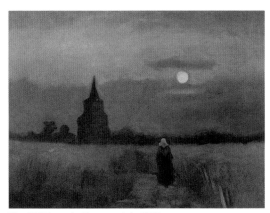

The Old Tower in Nuenen, July 1884

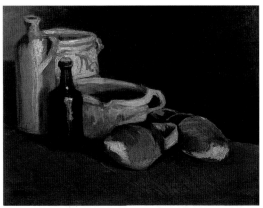

Still Life with Pottery and Clogs, Nuenen, November 1884

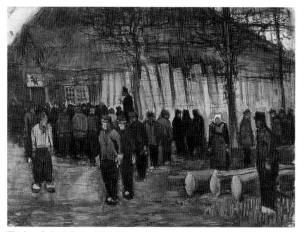

Timber Sale, Winter 1883/83

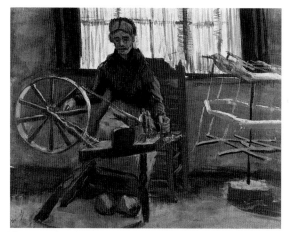

Woman at Spinning Wheel, Spring 1884

Chapel at Nuenen with Churchgoers, October 1884

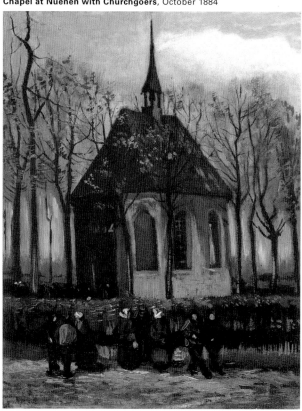

Road Lined with Poplars in Autumn, Nuenen, October 1884

In March **1885**, Vincent's father died from a stroke. Vincent stayed on at home for the time being, but soon took a place of his own in the village because his mother and sister were planning to move to Leiden.

He made countless preparatory studies for his first large oil painting, *Potato Eaters*. In May, he sent the painting to Theo who was not over-enthusiastic in his response to it.

Vincent broke with his long-standing friend Anthon van Rappard following his severe criticism of the painting, in particular its unsuccessful propor-tions.

On a visit to Amsterdam in the autumn, Vincent reacted enthusiasti-cally to the work of the Old Masters; Rembrandt and Frans Hals in parti-cular made a lasting impression on him.

In November 1885, now aged thirty-two, Vincent moved to Antwerp where he enrolled at the Academy for three months. He hoped to meet other artists and obtain commissions for portraits. He contacted local art dealers and was able to show his work in a gallery.

While in Antwerp, Vincent discovered Japanese prints.

Success eluded him, however, his debts began to mount again and his health deteriorated.

1885 Publication of the second volume of *Capital* by Marx.

In *Germinal*, Émile Zola describes the fate of miners in the coalfields of northern France.

Guy de Maupassant completes his novel *Bel-Ami*.

A major Delacroix retrospective is held in Paris.

The Parsonage in Nuenen, September/October 1885

Portrait of a Woman in Blue, Antwerp, December 1885

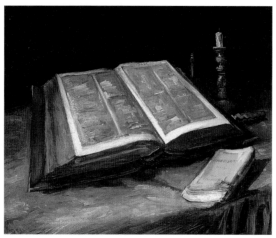

Still Life with Bible, October 1885

Still Life with Straw Hat and Pipe, Nuenen, September 1885

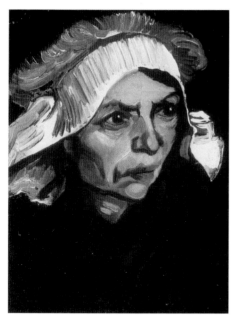

Head of a Peasant Woman with White Bonnet, 1885

Quay with Ships, Antwerp, December 1885

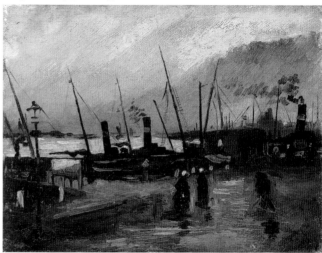

In March **1886**, Vincent decided at the spur-of-the moment to move to Paris. He moved in with his brother who was managing a branch of the art dealer's Boussod & Valadon, the new owners of Goupil & Co.

In June, the brothers moved into a large apartment in rue Lepic on the 'Butte', the still rural hill of Montmartre.

Vincent painted mostly still-lifes of flowers, the distant views from the windows and self-portraits, of which he produced twenty-one in Paris.

For a few months, he worked in the studio of Fernand Cormons, a Salon painter and teacher at the École des Beaux-Arts.

In Cormons' studio, he met Louis Anquetin, Henri de Toulouse-Lautrec and Émile Bernard. In the many local cafés and in the shop of Père Tanguy, a supplier of artists' materials with whom Vincent often spent time, he met other artists including Paul Signac and Alfred Sisley.

Theo introduced his brother to Camille Pissarro, while the art dealer Portier introduced him to Armand Guillaumin.

Van Gogh began collecting Japanese prints and considered dealing in them. They and his exposure to Impressionism and Pointillism influenced his palette, making it brighter.

1886 The eighth and final Impressionist exhibition is held in Paris; the second *Salon des Indépendants* is held.

Seurat exhibits his *Sunday Afternoon on the Island of La Grande Jatte*, an example of Divisionism.

Zola completes his novel about artists, *L'Œuvre*.

Construction work on the Sacré-Cœur in Montmartre completed.

Oskar Kokoschka born.

Official opening of the Statue of Liberty in New York City.

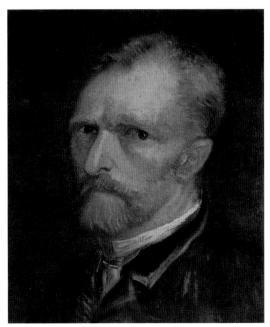

Self-Portrait, Paris, Autumn 1886

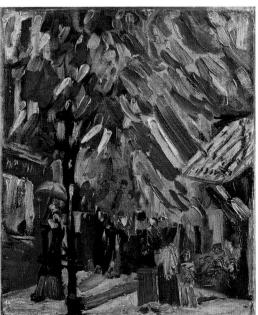

Street Scene in Celebration of Bastille Day, Summer 1886

Still Life with Mackerels, Lemons and Tomatoes, Paris, Summer 1886

The Roofs of Paris, May 1886

"I do not feel faint as long as I am painting, but in the long run those intervals are always sometimes rather too melancholy, and it grieves me when I don't get on, and am always in a bad fix."

Vincent to Theo
Antwerp, c. 15 December 1885

Vase with Poppies, Cornflowers, Peonies and Chrysanthemums,
Paris, Summer 1886

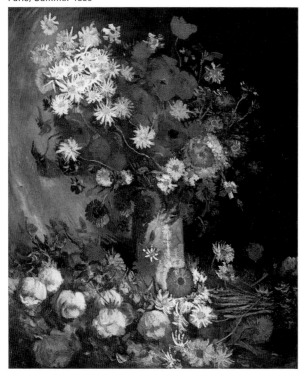

The Boulevard de Clichy, Winter 1886/87

A Pair of Shoes, Paris, late 1886

In spring **1887**, van Gogh and Signac often spent time painting together in and around Montmartre where they frequented working-class hostelries.

Van Gogh tried his hand at Pointillism and used a varied palette and vigorous brushstrokes. He included Japanese elements in his work.

That same year, he organised an exhibition of Japanese prints in the café Le Tambourin.

In the autumn, he exhibited his work alongside that of Signac and Seurat in the Théâtre Libre.

Van Gogh organised a further exhibition of the work of the 'Painters of the Petit Boulevard' – his name for the artists of Montmartre – in the Restaurant du Châlet. Over 100 works were exhibited, about half of them his own work. Anquetin and Bernard, with whom van Gogh worked, also participated in the show.

Van Gogh was able to exchange two of his works for a painting by Paul Gauguin, recently returned from Martinique. Van Gogh told his sister Wil (Willemien) of his plans to move to the south of France in the summer.

He hoped the South would help him not only make progress as an artist but above all benefit his poor health.

1887 The art dealer Siegfried Bing organises an exhibition of Japanese art for the *Central Union of Decorative Arts*.

Van Gogh, Seurat and Signac show their work in the foyer of the *Théâtre Libre* in Paris where a major Millet exhibition is also held.

Great Britain hosts the First Colonial Conference.

Construction work starts on the Eiffel Tower.

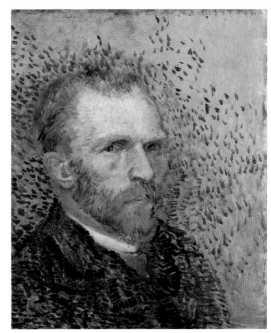

Self-Portrait, Spring 1887

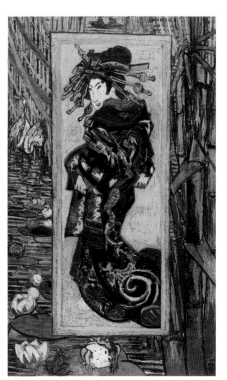

Oiran (after Kesaï Yeisen), 1887

Lilac, Paris, Summer 1887

Piles of French Novels and a Glass with a Rose, Paris, Autumn 1887

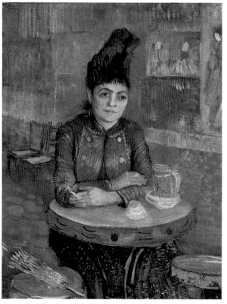

Agostina Segatori in the Café du Tambourin, Winter 1887/88

"Do you realize that we have been very stupid, Gaugin, you and I, in not going to the same place? But when Gaugin left, I still wasn't sure if I could get away, and when you left, that awful money business, and the bad reports I sent you about the cost of living here, stopped you from coming."

Vincent to Emile Bernard
Arles, c. 18 June 1888

Anglers and Boats at the Pont de Clichy, Paris, Spring 1887

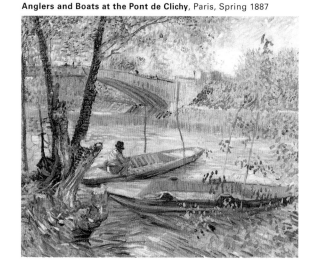

In February **1888**, van Gogh moved to Arles in the south of France where he hoped to establish a 'Studio of the South'.

One of the first pieces of news to reach him in Provence concerned the death of Anton Mauve.

In May, he rented the Yellow House on Place Lamartine that he hoped would soon be home to an association of artists.

Van Gogh found motifs to paint in and around Arles: besides paintings of orchards, fields and vineyards, he also produced numerous portraits. He also made several paintings of the night sky.

During his fifteen-month-long stay in Arles, van Gogh produced around 200 oil paintings, 100 (mostly pen) drawings and watercolours.

Theo sent examples of his brother's work to an exhibition of the Salon des Indépendants.

In June, van Gogh went on an excursion to the Mediterranean and returned with some studies from Saintes-Maries-de-la-Mer, a centre of pilgrimage.

From October, he shared his studio for three months with Paul Gauguin whose trip south was paid for by Theo. Before Gauguin's arrival in Arles, van Gogh had decorated his room with a series of paintings of sunflowers that became his best-known motif. Living together proved difficult for the two artists.

On 23 December, an argument escalated and Gauguin left the house. Van Gogh cut off a piece of his left ear lobe and handed it to a local prostitute. He returned to the Yellow House where his postman friend Joseph Roulin found him the next day; he took van Gogh to hospital. Gaugin left Arles.

1888 Wilhelm II proclaimed German emperor.

The artists' group, the *Nabis*, founded in Paris.

Bing starts publishing *Le Japon artistique*, a journal.

Field with Flowers, May 1888

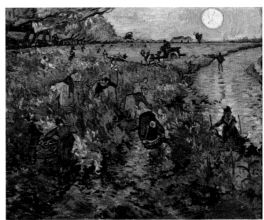

The Red Vineyard, November 1888

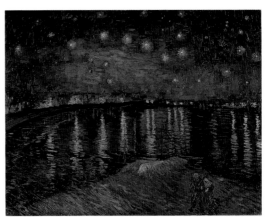

Starry Night over the Rhone, September 1888

The Bridge at Langlois with Women Washing, March 1888

The Sea at Les Saintes-Maries-de-la-Mer, June 1888

Willows at Sunset, Arles, Autumn, 1888

The Green Vineyard, c. 3 October 1888

The Dance Hall, late 1888

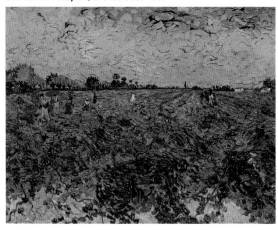

Immediately on being discharged from hospital in January **1889**, van Gogh began to paint again in Arles. He suffered from sleeplessness and delusions.

Only a month later, in February, he suffered a relapse and was re-admitted to hospital, but returned to his studio ten days later. Wanting van Gogh evicted, a number of local residents complained vociferously to the mayor who had him hospitalised.

Van Gogh finally agreed to be admitted to an asylum, voluntarily placing himself in the care of Dr Peyrons in the Saint-Paul-de-Mausole asylum at Saint- Rémy in May. He suffered repeated attacks and tried to poison himself with paint or solvents.

Between these serious attacks that prevented him from painting for about a quarter of his time, he was allowed to work, albeit under super-vision.

Van Gogh reworked old studies, painted two self-portraits and the mountains and cypress trees of Provence. He produced copies after Delacroix, Millet and Rembrandt.

Come the autumn of 1888, he was considering returning to the north of France as he blamed the Mediter-ranean climate for his illness.

In Paris in April 1889, Theo married Johanna Gesina Bonger, the sister of his friend Andries.

1889 The Eiffel Tower is completed and becomes the centrepiece of the World Fair that attracts twenty-eight million visitors.

Wassily Kandinsky visits Paris for the first time. The *Moulin Rouge* opens.

Path through a Ravine, December 1889

"I am happy to confirm that my friend Vincent has completely recovered; he will leave the hospital one of these days to return to his house. Do not worry, he is better than before that unfortunate accident happened ...; he is in a very healthy state of mind ..."

Joseph Roulin to Theo van Gogh
Arles, 3 January 1889

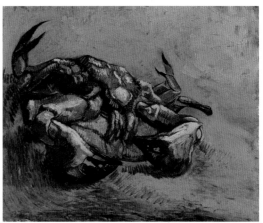

A Crab Up-side-down, January/February 1889

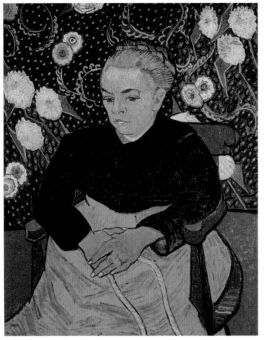

Augustine Roulin (La Berceuse), Arles, January 1889

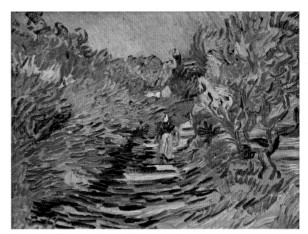

Woman on Tree-lined Road, December 1889

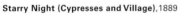
Starry Night (Cypresses and Village), 1889

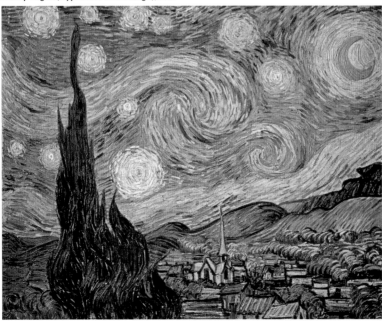

In January **1890**, an article about Vincent van Gogh – the first ever written – appeared in *Mercure de France*. Its writer, Albert Aurier, reviewed the artist's work enthusiastically.

For the sum of 400 francs, van Gogh sold his oil painting *Red Vineyard*, which had been on show in Brussels, to Anna Bloch, a member of *Les Vingt*, a group of painters and sculptors. This was the only piece of his work to be sold at the market rate.

Theo and Johanna's first child was born on 31 January and was baptised Vincent Willem.

In March 1890, ten paintings by van Gogh were exhibited at the Salon des Indépendants in Paris.

On 19 May 1890, van Gogh left the asylum at Saint-Rémy. He visited Theo and his family in Paris and then moved on to Auvers-sur-Oise, north of Paris, to be treated by Dr. Paul-Ferdinand Gachet, with whom he struck up a friendship. In the nine weeks he spent at Auvers, van Gogh produced over 100 landscapes and portraits besides trying his hand at etching.

In July, van Gogh paid another visit to his brother's family, but left suddenly to return to Auvers.

On 27 July 1890, while out walking, he shot himself in the chest with a pistol. He returned to his attic room where he died two days later with Theo at his side.

Van Gogh's funeral took place at Auvers-sur-Oise cemetery. Bernard and Tanguy, among others, travelled from Paris to attend it.

Theo van Gogh died six months later on 25 January 1891.

1890 Toulouse-Lautrec paints *Dance in the Moulin-Rouge*.

Egon Schiele born in Tulln by Vienna.

The first Underground railway runs beneath the Thames in London.

Rodin, Puvis de Chavannes, among others, found the *Société Nationale des Beaux-Arts* and organise their first exhibition.

Portrait of Dr Gachet with Pipe, June 1890

The Good Samaritan (after Delacroix), Saint-Rémy, May 1890

Branches of an Almond Tree in Blossom, February 1890

Trunks of Trees with Ivy, July 1890

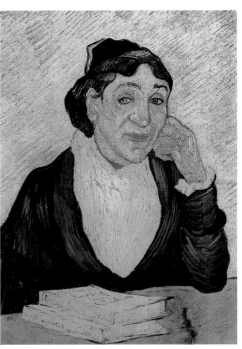

L'Arlésienne (Madame Ginoux), Saint-Rémy, February 1890

Undergrowth with Two Figures, 1890

List of Illustrations

Selected Bibliography

Whoever can read, should do so!
Vincent to Theo, October 1979

Druick, Douglas W. and Peter Kort Zegers: *Van Gogh and Gauguin. The Studio of the South*, exhib. cat. (The Art Institute of Chicago), New York/London 2001

Faille, Jacob Baart de la: *The Works of Vincent van Gogh. His Paintings and Drawings*, New York 1970

Hammacher, A.M. and R.: *Van Gogh: A Documentary Biography*, London 1982

Heugten, Sjraar van: *Vincent van Gogh. Drawings 1, The Early Years 1880–1883*, (Van Gogh Museum), Amsterdam 1996

Heugten, Sjraar van: *Vincent van Gogh. Drawings 2, Nuenen 1883–1885*, (Van Gogh Museum), Amsterdam 1997

Heugten, Sjraar van: *Vincent van Gogh. Drawings 3, Antwerp and Paris 1885–1888*, (Van Gogh Museum) Amsterdam 2001

Homburg, Cornelia et al: *Vincent van Gogh and the Painters of the Petit Boulevard*, exhib. cat. (Saint Louis Art Museum), New York 2001

Hulsker, Jan: *The New Complete Van Gogh. Paintings, Drawings, Sketches*, Amsterdam/Philadelphia 1996

Kōdera, Tsukasa (ed.): *The Mythology of Vincent van Gogh*, Amsterdam 1993

Kooten, Toos van and Mieke Rijnders (eds.): *The Paintings of Vincent van Gogh in the Collection of the Kröller-Müller Museum*, Otterlo 2003

Nemeczek, Alfred: *Van Gogh in Arles*, Munich/London/New York. 2001

Pickvance, Ronald: *Van Gogh in Saint-Rémy and Auvers*, New York, 1986

Pickvance, Ronald: *'A Great Artist is Dead'. Letters of Condolence on Vincent van Gogh's Death*, Zwolle 1992

Pollock G. and F. Orton: *Vincent van Gogh: Artist of his Time*, Oxford 1978

Rijksmuseum Vincent van Gogh (ed.): *Vincent van Gogh. Paintings. Drawings*, 2 vols, exhib. cat., Milan 1990

Roskill, M.: *Van Gogh, Gauguin and the Impressionist Circle*, London 1970

Stein, Susan Alyson: *Van Gogh. A Retrospective*, New York 1986

Stolwijk, Chris et al: *Van Gogh's Imaginary Museum: Exploring the Artist's Inner World*, New York 2003

Sund, Judy: *True to Temperament. Van Gogh and French Naturalist Literature*, New York 1992

Sund, Judy: *Van Gogh*, London 2002

Tilborgh, Louis van and Marije Vellekoop: *Vincent van Gogh. Paintings 1. Dutch Period 1881–1885*, Amsterdam (Van Gogh Museum) 1999

Uitert, Evert van, Louis van Tilborgh and Sjraar van Heugten: *Vincent van Gogh. Paintings*, exhib. cat., Amsterdam 1990

Vollard, Ambroise: *Recollections of a Picture Dealer*, Zurich 1936, repr. London 2003

Vriend, Anita: 'The Sketches in Vincent van Gogh's Letters', in *Van Gogh Bulletin V*, 1990, no. 2

Welsh-Ovcharov, Bogomila: *Van Gogh in Provence and Auvers*, 1999

Wolk, Johannes van der: *De Schetsboeken van Vincent van Gogh*, Amsterdam 1986

Zemel, Carol: *The Formation of a Legend. Van Gogh Criticism, 1890–1920*, Ann Arbour/Michigan 1980

Writings and Correspondence:

Verzamelde Brieven van Vincent van Gogh, 4 vols, Amsterdam 1952–54; English translation in 3 vols, Greenwich, CT 1958 / R London 1977

Letters of Vincent van Gogh, 1886–1890, A Facsimile Edition, London 1977

Barbillon, Claire and Serge Garcin: *Lettres illustrées de Vincent van Gogh (1888–1890)*, 3 vols, Paris 2003

Crimpen, van, Han and Monique Berends-Albert (eds.): *De brieven van Vincent van Gogh*, 4 vols, 's Gravenhage 1990

Location of Key Works

Index

Numbers in italics refer to pages with illustrations

Front cover: *The Bridge of Langlois*, March 1888, see fig. on pages 7, 131
Back cover: *Iris*, 1889, see fig. on page 29, 99
Page 2: Self-portrait Saint-Rémy, September 1889, oil on canvas,
 65 x 54 cm, Musée d'Orsay, Paris
Page 4: *Fishing Boats on the Beach of Saintes-Maries*, June 1888, detail,
 watercolor, 39 x 54 cm, private collection
Page 116: *Self-portrait*, November/December 1888, oil on canvas,
 46 x 38 cm, The Metropolitan Museum of Art, New York

The illustrations in this publication have been kindly provided by the
museums, institutions and archives mentioned in the captions, or taken
from the Publisher's archives, with the exception of the following:
akg-images, Berlin: pages 7, 9, 15, 17, 24, 33, 69, 82/83, 90, 97, 130, 131
(center and below right)/akg-images, Erich Lessing: pages 19, 86, 103,
133/akg-images, electa: pages 29, 112
Artothek, Weilheim: pages 2, 13, 21, 27, 60/61, 70/71, 95, 99, 109, 115,
116/Artothek, Christie's: page 94/Artothek, Joachim Blauel: pages 5, 11,
46, 51, 64, 76/77, 131/Artothek, Hans Hinz: pages 23, 113, 130, 133/
Artothek, Peter Willi: pages 31, 101

© Prestel Verlag, Munich · Berlin · London · New York 2005
Third printing 2010

Prestel Verlag, a member of Verlagsgruppe Random House GmbH

Prestel Verlag
Königinstrasse 9
80539 Munich
Tel. +49 (0) 89 24 29 08-300
Fax +49 (0) 89 24 29 08-335

Prestel Publishing Ltd.
4 Bloomsbury Place
London WC1A 2QA
Tel. +44 (0) 20 7323-5004
Fax +44 (0) 20 7636-8004

Prestel Publishing
900 Broadway, Suite 603
New York, N.Y. 10003
Tel. +1 (212) 995-2720
Fax +1 (212) 995-2733

www.prestel.com

Prestel books are available worldwide. Please contact your nearest book-
seller or one of the above addresses for information concerning your
local distributor.

The Library of Congress Control Number: 2009928897
British Library Cataloguing-in-Publication Data: a catalogue record for
this book is available from the British Library. The Deutsche Bibliothek
holds a record of this publication in the Deutsche Nationalbibliografie;
detailed bibliographical data can be found under: http://dnb.ddb.de

Translated from German by Stephen Telfer, Edinburgh

Copyediting by Christopher Wynne, Munich
Design and layout by Andrea Mogwitz, Munich
Production by Fabian Kornher
Origination by Reproline Mediateam, Munich
Printed and bound by Druckerei Uhl GmbH, Radolfzell

FSC
MIX
Papier
FSC® C004229

Verlagsgruppe Random House FSC-DEU-0100
The FSC-certified paper *Hello Fat Matt* is produced by
mill Condat, Le Lardin Saint-Lazare, France

Printed in Germany

ISBN 978-3-7913-4396-9